BLACK
SUN

THE

EYES OF

FOUR

細江英公

東松照明

深瀬昌久

森山大道

EIKOH HOSOE

SHOMEI TOMATSU

MASAHISA FUKASE

DAIDO MORIYAMA

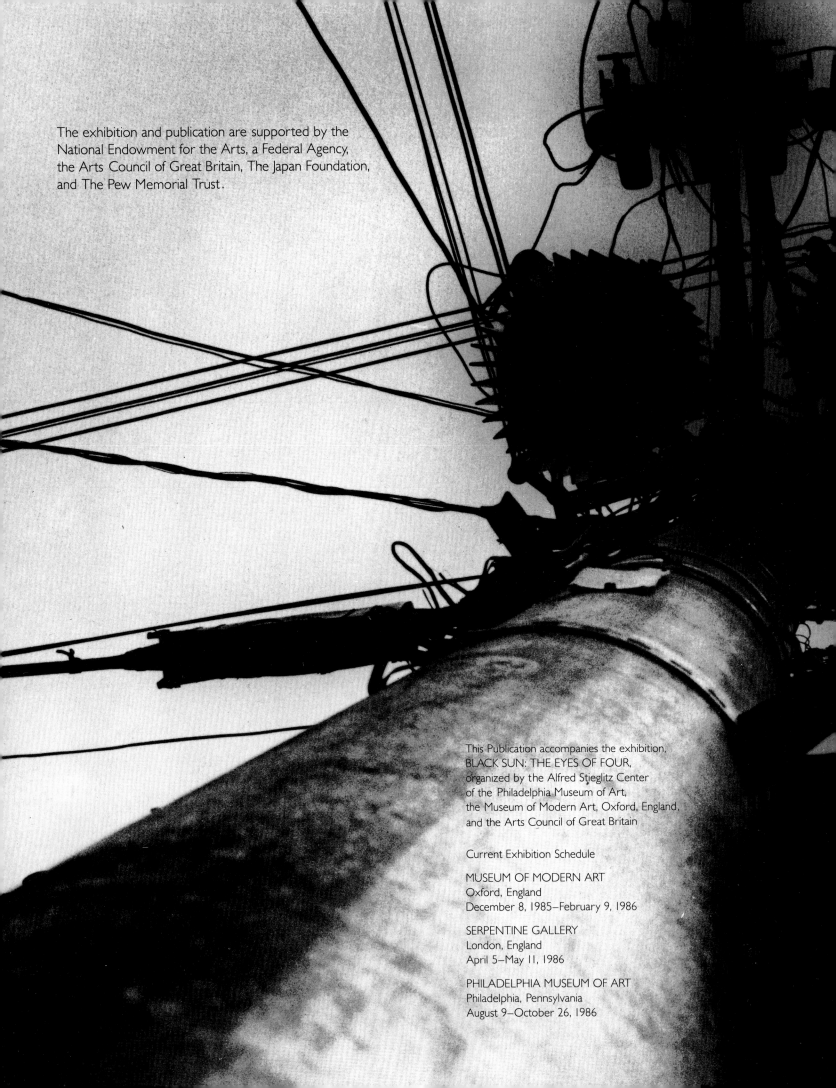

The exhibition and publication are supported by the
National Endowment for the Arts, a Federal Agency,
the Arts Council of Great Britain, The Japan Foundation,
and The Pew Memorial Trust.

This Publication accompanies the exhibition,
BLACK SUN: THE EYES OF FOUR,
organized by the Alfred Stieglitz Center
of the Philadelphia Museum of Art,
the Museum of Modern Art, Oxford, England,
and the Arts Council of Great Britain

Current Exhibition Schedule

MUSEUM OF MODERN ART
Oxford, England
December 8, 1985–February 9, 1986

SERPENTINE GALLERY
London, England
April 5–May 11, 1986

PHILADELPHIA MUSEUM OF ART
Philadelphia, Pennsylvania
August 9–October 26, 1986

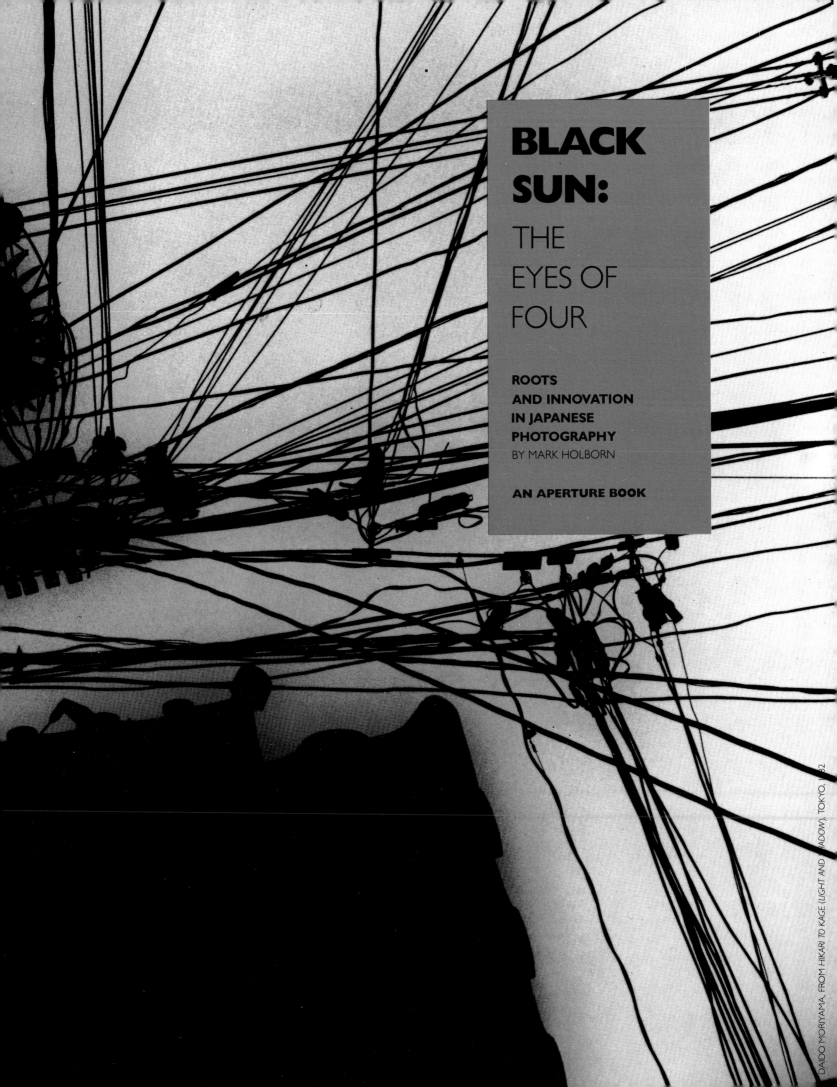

BLACK SUN:

THE EYES OF FOUR

ROOTS AND INNOVATION IN JAPANESE PHOTOGRAPHY

BY MARK HOLBORN

AN APERTURE BOOK

ACKNOWLEDGEMENTS

Special thanks are extended to Tatsuo Fukushima, who has acted as a special advisor to this project from its conception, and to the photographers Eikoh Hosoe, Shomei Tomatsu, Masahisa Fukase, and Daido Moriyama for their generosity and cooperation at all times. This publication would not have been possible without the help of the following individuals: Martha Chahroudi (Philadelphia Museum of Art), Andrew Dempsey (Arts Council of Great Britain), David Elliott (Museum of Modern Art, Oxford), Mark Haworth-Booth (Victoria and Albert Museum, London), Tatsumi Hijikata, Kikuji Kawada, Rei Kawakubo, Donald Keene, Kazue Kobata, Mutsuko Murakami, Dorothy Norman, Akiko Otake, Yoichi Shimizu (The Japan Foundation), Hiroko Takekoshi, Tetsuya and Kazuko Uehara, Osamu and Akira Uehara, Glyn Williams, Tadanori Yokoo.

ISBN: 0-89381-185-8 L.C. 85-72539
Duotone negatives by Robert Hennessey. Printed and Bound in Italy by Amilcare Pizzi, S.p.A. Milan.

Book design by Betty Binns Graphics/ Betty Binns and David Skolkin.

Aperture, a division of Silver Mountain Foundation, Inc., publishes a periodical, books, and portfolios of fine photography to communicate with serious photographers and creative people everywhere. A complete catalogue is available upon request. Aperture, 20 East 23 Street, New York 10010.

The staff at Aperture for *Black Sun: The Eyes of Four* is Michael E. Hoffman, Executive Director; Christopher Hudson, Publishing Director; Mark Holborn, Editor; Lawrence Frascella, Managing Editor; Katherine Houck, Production Associate; Susan Coliton, Development Director; Andrew Semel, Eileen Smith, Work Scholars.

TEXT CREDITS

The quotes in this text are reprinted through the kind permission of their publishers: p. 16 Copyright © 1939 Auden, W.H. and Christopher Isherwood. *Journey To War*. London: Faber & Faber, New York: Random House, Inc. p. 33 Tomatsu, Shomei. *Shomei Tomatsu, Japan 1952–1981*. Graz: Edition Camera Austria, 1984; p. 48 Sakaki, Nanao. "MEMORANDUM" in *REAL PLAY*. New Mexico: Tooth of Time Publishers, 1983; p. 49 Snyder, Gary. "The Journeys North and South" in *Cold Mountain*. San Francisco: Grey Fox Press, 1958; p. 64 Hersey, John. *HIROSHIMA*. New York: Alfred A. Knopf Inc., 1946, Copyright © renewed 1974 by John Hersey; p. 65 Abé, Kobo. *THE RUINED MAP*. Translated by E. Dale Saunders. New York: Alfred A. Knopf Inc., 1969; p. 67 Herzog, Werner in TOKYO-GA, a film by Wim Wenders, Copyright © Chris Sievernich–Wim Wenders Film Production, 1984; back cover Ito, Shunji. *Shomei Tomatsu, Japan 1952–1981*. Graz: Edition Camera Austria, 1984.

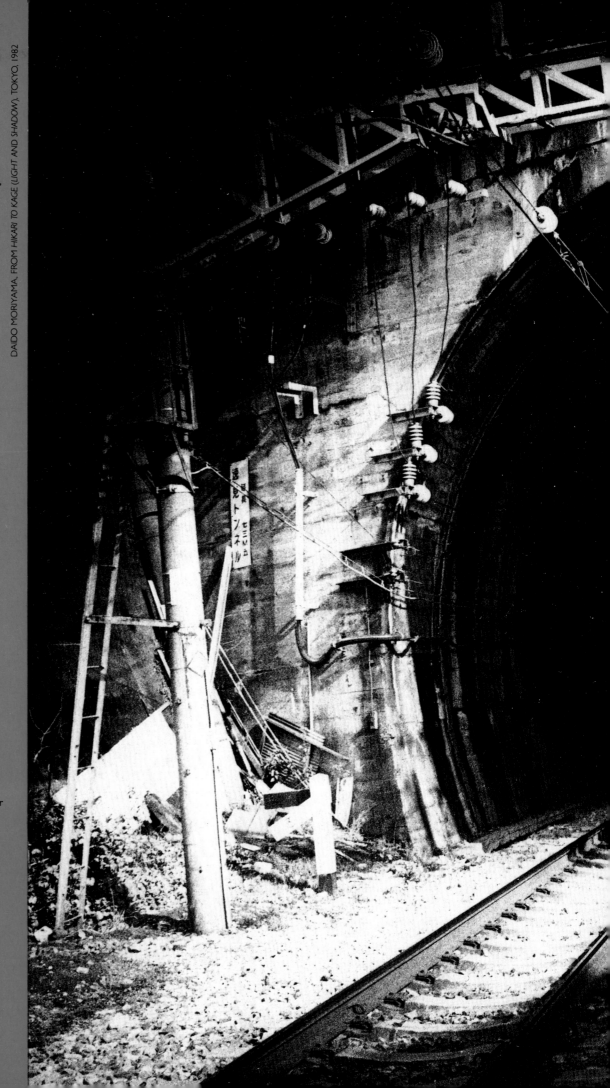

DAIDO MORIYAMA, FROM HIKARI TO KAGE (LIGHT AND SHADOW), TOKYO, 1982

PAST
AND
PRESENT

The last few minutes of a flight, when you stare from a window to gauge the landscape of a new territory, are strangely deceptive. International airports carry the names of great global centers, yet their runways cross open country miles from urban landmarks. It takes only seconds to go from the Pacific coast to the new airport at Narita. On the ground Tokyo glows over the horizon as night falls or stains the sky yellow in the full light of day. The open fields passed on the expressway, the rice terraces, the clusters of bamboo forest are reminders of the proximity of farming to the hub of the capital. A cultivated landscape lies next to a blazing nocturnal city. A distant pagoda rises above a cut in a hillside. The connotations of history end at the Edo River, a barrier on the city borders, after which a fishing village was named that grew into a metropolis. In motion on a six-lane highway, vision framed by a windshield, the experience is cinematic rather than purely photographic. Disneyland and the silhouette of Cinderella's castle on one side; housing blocks as bleak as the periphery of an Eastern European suburb to the other side; the towers of Shinjuku ahead.

The highway travels above the ground. The car flies past the windows of offices. Calligraphic signs confirm the Oriental location. Canals, traffic congestion, and the gray concrete fabric give way to tree-lined grassy banks and the moat of the Imperial Palace. Nearby the vertical thrust of a white hotel designed by Kenzo Tange is exaggeratedly close to the lines of space travel.

The traditional modules on which Japanese architecture based its modernity have been displaced by flamboyant postmodernism. A corporate headquarters near the Diet looks like inflated white kitchenware; the bronze reliefs surrounding the ground floor are somewhere between Robert Longo and props from *Star Wars*. Portholes punctuate the flush planes of another hotel. The promise of this architectural endeavor is a capsulated existence. The route from the airport to Shinjuku corresponds to the line from an agrarian past, with views of the preserved imperial domain, to a future mapped on drawing boards in an effusion of white monuments. From international airport to Imperial Palace is a nation flourishing on internationalism yet fervently insular. The car windows are shut to maintain the air conditioning and to avoid the poisons of the traffic. The view is silent and detached. The journey acquires the sense of flight. The futurist fantasies are founded on archaic history, realized from an unprecedented loss in the course of a single generation.

The rainy season has officially been declared over, and it has rained torrentially ever since. The concrete of the city sprouts grass and weeds. As the rains pass, mosses appear beside pools, along paths, and under eaves. The fabric of the city bursts and cracks. Cement and mortar are vulnerable materials challenged by the volatile force of the season, let alone the shudder of earthquakes. The random lines of repaired surfaces of steps and walls form sprawling veins. The eye scans the ground at one's feet or the wall of an alley. When photographers first arrived in Japan they worked to encompass scenic vistas with depth and distance, perhaps in reference to the Oriental landscape that they imagined from great Sung paintings or Ukiyo-e prints. The Japanese eye was guided by the sparseness of interiors to immediate focal points—the grain of a wood floor, the curve of a bowl, the pattern on a lacquer box, a chrysanthemum crest on the head of a nail, the moss around stepping stones. Space seen flattened. Perspective and depth were created by constructed illusions. This emphatic surface often distinguishes the most significant photographs made by Japanese from Western photography with its wide vocabulary. Whereas the surface has provided the challenge and the tension of so much Western painting throughout this century, there is no vital tradition of contemporary Japanese painting; it is still emerging. Photography with its speed and fluidity has become a most appropriate medium for a peculiarly Japanese expression. The surface can accommodate great depths. Tokyo is a composite of layered surfaces. Behind the streaked concrete of the facade, the cracked skin of the city, is an interior city marked by the collective memory of the nation.

The rains evaporate in the steamy heat. A haze hovers beneath storm clouds. The beating of drums in the summer nights signals the festive season of Bon Odori. Fireworks explode across the Tokyo plain. The austere concrete of the new housing on the edge of town, or the shopping center like a recent complex in Alabama, Frankfurt, or a suburb of London, is now dark but flashes beneath sparks and explosive clusters. The rhythm of the drums is persistent. The same song is heard every night through a loudspeaker. I watch the lights through binoculars. The nocturnal city is finding its pulse. The lanterns hanging outside the low shop buildings of an old quarter are reminiscent of a scene from an Edo print. On the outskirts of the city, in an area that before the war was farmland and forest crossed by a single railway track, a tall concrete tower looms. Radar antennas beam from the tower over housing blocks. Then a great switch is pulled and the lights turn on in thousands of homes below. The circuit of the city flows. Einstein could never understand how the Japanese, with their scarcity of resources, could burn so much electricity. On my way back through the quiet residential streets I pass the dome of an astronomical telescope.

In the full midday heat of Asakusa, the old downtown or East End of Tokyo, I stand on the Azumabashi Bridge by the Asahi Brewery. The river is blue. The pale blue paint of the bridge is peeling. Trains cross the river on the next steel bridge. The scene, despite its motion and color, seems monochrome. The internal reference may be the déjà-vu of cinema. This movie is fifties black and white. It is the city of the immediate postwar years. I follow the alleys to the crowd at Sensoji temple. There is the familiar smell of incense. Pigeons perch in the eaves. There are fairgrounds; empty bars; stalls selling old clothes, wigs, and watches; charcoal smoke; tourists on stopovers. By the time I reach Ueno the crowds have swollen in the markets, drawn by the summer heat. Families gather beneath the trees in the park, watch the fountains, and photograph the pigeons. I follow the back streets to Yanaka, the adjacent quarter. Untouched by the firebombs, the old wood houses echo Edo. Here is the edge of Ukiyo-e, the Floating World. The lanes of Yanaka are cluttered with temples. Clouds of incense and stonemasons' shops suggest the proximity of the cemetery. The tombs are cleared from the undergrowth, rubbish blows against the stones, discarded pornography is trodden in the mud. The graves end at the railway track. I stand on the footbridge, wire mesh to my sides, the trains passing beneath me, the cemetery behind my back, and the rooftops of Tokyo spreading out to Narita and the open country before me. Small clouds float in a brilliant sky. I am on the edge of the lands of the living and the dead. It is the first day of summer.

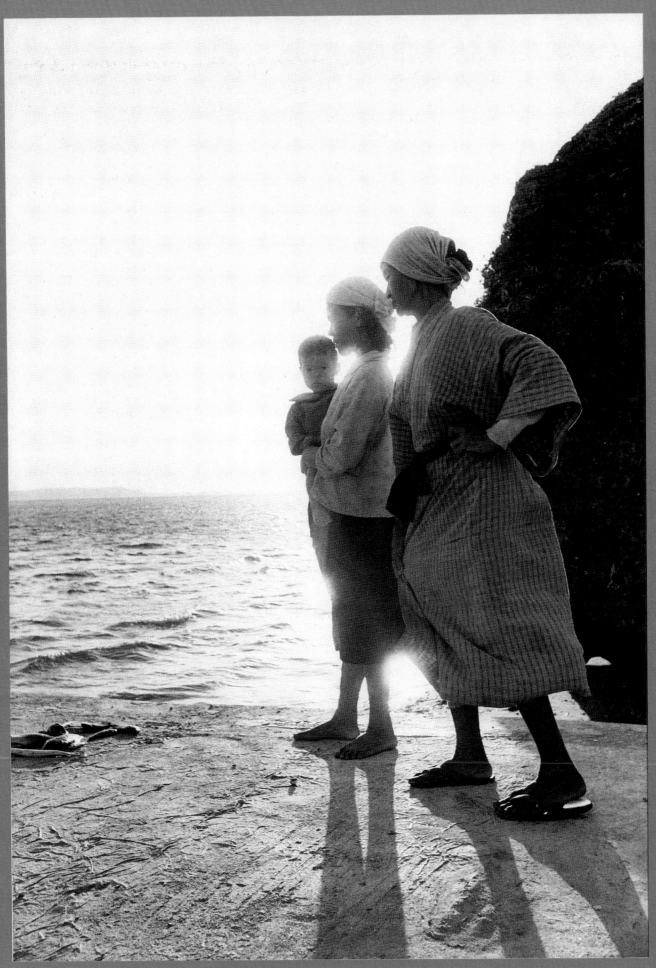

SHOMEI TOMATSU, OGAMI ISLAND, OKINAWA, 1969

On a wall by Shinjuku Station, next to a large screen projecting twenty-four-hour video, is a large digital clock. The clock counts down the days until the opening of Tsukuba Scientific Expo 85, an event that will indicate technological patterns for the rest of the century. The Osaka Expo in 1970 had signaled Japan's economic confidence. At Osaka the flamboyance of a new nation was evident in the audacious construction of a textiles pavilion by the young designer Tadanori Yokoo. The building had flaunted scaffolding and the red cutout silhouettes of workers. It signified an edifice in transition. Fifteen years later the Tsukuba Expo had arrived like a telegram from the twenty-first century. The vocabulary was digital, and the subtitles were in Japanese. Tokyo may look like a set for a science-fiction movie—Andrei Tarkovsky had indeed filmed a Tokyo expressway for his epic *Solaris* (1971)—but the model of Japan as a futurist sphere can be as redundant as computer hardware can be superficial. The ability to embrace Tsukuba while simultaneously uncovering a chart of an insular history describes the significant route for Japan. A map of that interior geography is the first requirement for crossing the gulf between Japan and the West so explicitly blasted out of history at Pearl Harbor on December 7, 1941.

On that day, as the aircraft of the Japanese Imperial Fleet launched their attack on the American fleet, Toyo Miyatake, a Japanese photographer in Los Angeles, photographed a wedding. The bride and groom of this white wedding were also Japanese. The day of their union coincided with the commencement of Pacific hostilities that would end in 1945. Miyatake's simple wedding photograph aligned a private union with a historical gulf that, despite forty years of guilt and questioning, we still have not crossed. While the American fleet smoldered in mid-Pacific, the wedding reception was interrupted by the FBI, who removed several of the guests. By May 3, 1942, the Japanese army had occupied most of Southeast Asia and the President of the United States had issued Order 9066 instructing all persons of Japanese ancestry to report to Civil Control Centers, after which they were deported to prison camps. Miyatake smuggled a lens behind the barbed wire of Manzanar Camp in California, where he was relocated. During his confinement he managed to design and organize the construction of a camera with which he documented the life of the imprisoned Japanese community. Remarkably, Miyatake became overt in his activity because one of the guards admired the work of Edward Weston and allowed him to continue. The pattern of daily life was vigorously maintained in response to the traumatic upheaval of collective imprisonment. Oaths of loyalty to the United States were solicited. Having confirmed allegiance to their host nation, young men were released to enlist in the American armed forces, where they fought heroically.

Toyo Miyatake's life work was published in Tokyo in 1984 through the support of the photographer Eikoh Hosoe. Hosoe's work, which is often theatrical and autobiographical, is also a measure of his relationship with the West. One of his ambitions is to complete his translation of Edward Weston's *Daybooks*. He has recently completed his major study of the Catalan architect Gaudí from a Japanese and a Buddhist perspective. His work has native roots but also serves a hybrid international culture, which may describe the essential Japanese quality. In the same week as Miyatake's book was published, nearly fifty thousand Japanese visited an exhibition of photographs by Robert Capa in a Tokyo department store. Capa's death as a war photographer clearly reflected the Japanese people's sense of their own tragedy. The tension of Tokyo has become more than a dialogue between East and West. Tokyo is a city that reasserts its past as it maps its future. It grows in opposite directions simultaneously with a motion as impossible as the cleavage of the atom, which only Japan has experienced so directly.

It is ironic that the military occupation of Japan, planned by the Americans with such consideration for cultural conditions and resulting in such long-lasting cultural traffic, was preceded by the exercise of so great a military force on a predominantly civilian population. The first step to bridging the gulf between Japan and the West came in the wake of Hiroshima and Nagasaki. It is ironic that the Japanese, who throughout history had absorbed foreign culture so enthusiastically, were subjected to Americanization at the hands of an unprecedented military presence. Both Japan and the West had to demolish the status of demonic foe with which they had endowed each other.

While Americanization accelerated in Japan, Japanese studies flourished in the West. The writers and scholars Kenneth Rexroth, Donald Keene, and Gary Snyder provided invaluable access to the Japanese imagination. Snyder went far beyond the role of interpreter or translator, challenging the exotic notions of Japan and working and writing among those Japanese who were searching for the roots of their own culture in the face of the economic miracle of the sixties. He exercised the role of poet in the physical work of a remote farming community that linked him to the primary archaic culture of Japan. Keene gained an understanding of Japanese literature and theater that enabled him to address a Japanese audience as articulately as he enlightened the West.

However, Japan's phenomenal postwar economic development was not tangible to the West beyond the facade of a trade fair or statistics until in 1971 the photographer W. Eugene Smith began documenting the environmental disaster of Minamata, a fishing village in southern Japan smitten by mercury poisoning. Minamata became a global symbol for corporate exploitation in disregard of human life.

The Western view of modern Japan was clouded by the success of an expansive Japanese free-trade system that threatened Western economic stability. The success was tarnished by attendant pollution and physical suffering. Japan was popularly characterized either in terms of a quaint tradition for the indulgence of exotic tourism or as an economic monster undermining Western markets. Behind the myth of the postwar development little was understood of the crisis and creative expression that accompanied such drastic upheaval from nuclear defeat, the guilt of war crimes, the dismantling of the divine institution of the emperor to recognition in world affairs as a great inventive and industrial source. The assertion of economic viability so dramatically demonstrated at the Osaka Expo of 1970 paralleled a remarkable artistic development that turned away from Western models to assert an identity that was exclusively Japanese. The significance stretches far beyond a transformation peculiar to Japan. A question underlies the Japanese experience that touches the heart of national identity. The currents of contemporary commercial exchange imply a future where the distances of geography diminish, an international culture surfaces, and the interior map we carry with our language and our memory is displaced by a code of global statistics. The photographer Frederick Sommer succinctly stated that the world was not a world of cleavages at all and that "circulation of the blood was circumnavigation of the world." The first step to recognizing the universal circuits is to acknowledge the national roots. Circumnavigation is possible when we recognize the distance of history that separates us. In Japan there is a terrible yet fertile experience. Photographs provide the unmitigating evidence.

THE
OBJECTIVE
EYE

THE giant video screen is visible from the platforms of Shinjuku Station. Its sepia tones glow over the adjacent square. The screen projects a contortion of giant bodies beside a backdrop of buildings and a bombardment of advertising. The walls of Shinjuku can be consumed like the visions of Times Square or the surfaces of a Calvin Klein mural. Scale exaggerates the impact of images absorbed as passively as the eye scans the multiple racks of magazine covers or the colors of shoes behind the glass of a shopwindow. The language surrounding the screen is calligraphic. The Western alphabet is employed, not for meaning but for graphic effect. The language is a reflection of both the proximity and the distance between Tokyo and the West. The only information beyond the imagery of the square is the digital countdown to the futurist dream of Tsukuba.

Behind the square lies the maze of Kabuki-cho, the modern pleasure quarter of cinema, stripjoint, and prostitution, inhabited by a predatory public. It is the domain of the *ya-kuza*, the gangster, and the marketplace of the racketeer. Unlike the entertainment quarters of Akasaka or on the periphery of the Ginza, it is neither discreet nor refined. Kabuki-cho is as theatrical as its name implies. It has a facade of brilliant color, the garish packaging of flesh. Kabuki-cho is the stalking ground of voyeurs in a city where voyeurism is the most obvious

On the circular stage of a basement theater the girls revolve beneath the spotlight, exposed to intense gaze. A more private and explicit drama than the spectacle of the street is enacted. A girl in a transparent air hostess's suit descends clutching a bag to perform favors on the small audience. Meanwhile on the stage the culmination of the display occurs when the stripper hands the audience a loaded Polaroid camera. The voyeurism is consummated in the possession of the girl's body on **SX-70** film. Photographs are the currency of voyeurism. The magazines titillate with pictures of private acts uncovered by photographers who on the long summer evenings roam the grounds of Shinjuku Gardens with infrared film.

To compare the consumerism of a photographic act with photographic art is misleading. Tokyo is a city of consumerism heightened to spectacular dimensions. Voyeurism, which was a significant characteristic of the Shunga erotic-print tradition of Edo, remains an erotic cue. The city is also the capital of the greatest camera-manufacturing nation in the world. Technological ingenuity and graphic sensibility, coupled with a hunger for the consumption of the image, suggest and confirm a national preoccupation with photographic practice. The best Japanese photography is significant because it is powerful enough to challenge the ephemeral image bank of the city. An extraordinary Japanese photography has emerged not only as a product of this environment but despite it. Inevitably, certain key photographic work reflects those predatory instincts in a society of hunters who have one finger on the video replay and the other on the button of the **SX-70** as the girl turns on the stage and drops her hands.

The back streets of Shinjuku are no more than the transparent wrapping on the elusive qualities that constitute modern Japan. That garish surface, however, is repeated in every city from Hokkaido to Okinawa. Photography, with its facility for recording the veneer of things, unavoidably reflects the imagery of the wrapping, especially in an environment where the eye is constantly drawn to surfaces.

Two challenges are predominant. The photographer can confront the visual chaos of urban density like that of Shinjuku and develop an assertive strategy to use the chaos and incorporate and even exaggerate it in the form of the photographs. Alternatively, the photographer can work to penetrate the veneer to find a subject matter that transcends the chaos. This work involves a metaphorical journey to the elusive core of the Japanese experience, bounded on one side by a mythical history and a traumatic national experience and on the other side by a heightened awareness of the future. This latter method invokes the memory and suggests that photog-

the present. Freezing the moment becomes a tool for uncovering the past, even for describing the narrative of one's autobiography. Both challenges demand a method of perception unlike anything in the Western tradition. To see the most demanding and powerful modern Japanese photography for what it is, you must look again as if you had been implanted with the eye of another animal.

The roots of a photographic style peculiar to Japan follow a pattern characteristic of Japanese assimilation. Chinese cultural attributes like calligraphy, sericulture, and T'ang architecture were imitated by the Japanese, absorbed into their own cultural domain like the tea ceremony, *cha-no-yu*, then Japanized or marked with characteristics that accord them a special Japanese identity. This assimilative ability has been most obviously extended to modern industrial enterprise. The automobile industry might appropriate design elements of small European models but finishes with a product that is Japanese. The unique process of Japanese transformation occurs after a long period of careful imitation.

Photography arrived in Japan when Commodore Perry's "Black Ships" opened the country to the West in the mid-nineteenth century. By the 1860s Felice Beato, a traveler and photographer of Venetian origins, who had photographed the aftermath of the Indian Mutiny at Lucknow in 1858 and had accompanied the British Expeditionary Force to China in the Opium War in 1860, had established a photographic studio in Yokohama. His two albums, one of views of Japan and the other of portraits of all elements of Japanese society, were published in 1868 and form a remarkable document of a time when Western intrusion had not yet radically transformed the country. The albums contain pictures of a refined yet almost innocent society untainted by the pressures of the outside world. They also stirred the imaginations of subsequent photographers. Japan became depicted as a land of cherry blossoms and scenic vistas. The enthusiasm for Japonisme promoted a new sense of spatial arrangement in a number of Western artists but also reduced Japanese characteristics to a set of decorative motifs.

Photography also reached Japan by a northern route from Siberia. The colonization of Hokkaido in the late nineteenth century was photographically documented, and portrait studios were established on the northern island. In the years before World War II photography appears very much in its first imitative phase. Pictorial styles were adopted from the West and genres of nudes and portraits imported. Refined surrealist collage effects and photograms were used by a number of prewar artists. Social suffering

were displaced by the propagandist state whose imagery corresponded to the Japanese militarism and expansionism of the thirties.

The events of 1945 in Europe and Japan challenged the role of the photographer in a different way from the brutality photographers have encountered over the last two decades. The events of that year were unprecedented. Never before had unthinkable stacks of bodies been arranged in photographic compositions to contradict all notions of the European historical course of civilization. In the same way the aftermath of an incendiary raid on Tokyo (let alone the devastation of Hiroshima or Nagasaki) was an almost impossible subject matter. Such photographs are no longer addressing people or the media but an abstract historical conscience. The camera was a vehicle not for the grief of the photographer but for absorbing the evidence, just as scientists measured the levels of radioactivity at Hiroshima. The camera shielded the photographer with a sense of objective precision. The dispassionate method of gathering the evidence was effective by virtue of its understatement. To document the recovery of daily life in the immediate postwar years in Japan under occupation required a methodical practice. Circumstances demanded a seemingly dispassionate, clinical eye. The propagandist era of the thirties had bred a great lie across Europe. In Japan the traits of a fascist visual vocabulary had been imposed like State Shinto on a volatile and patriotic youth, using a language of steel, imperial crests, and solar insignia. Glorious death in the service of the emperor was matched by the inglorious and anonymous death of thousands of civilians. The only remaining response for a photographer in a defeated Japan in the daze of atomic weapons and of surrender was a belief that the camera could counter the distortions of history that had incited the emotions of the prewar nation. The camera was the instrument of truth.

The occupying forces' dismantling of State Shinto, which had controlled the education system and joined state and religion, freed the activities of the intellectuals, who previously had been prevented from discussing Western radical or socialist ideas. The late forties was a period of considerable intellectual energy, with the appearance of a great number of new literary magazines. By the fifties groups such as Democrat, organized by the critic Tatsuo Fukushima, exposed young writers and artists to the postwar literature of Sartre and Camus, inspiring an imported existentialist mood appropriate to the Japanese response to catastrophe and its aftermath. This new intellectual freedom coincided with the overthrow of the basic concept behind the chauvinism of Japanese prewar militarism—but also the heart of Japanese myth—the divinity of the emperor.

A form of social realism then revived a common passionate ideology that had been dormant for a generation. This "objective" realism was headed by Ken Domon, the outstanding photographer of the early postwar years. Domon's background was radical. He had been arrested in 1932 for his involvement with a farmers' union and was subsequently expelled from Nihon University, where he was a law student. In 1950 he was instrumental in the formation of the Shudan Photo Group, which rejected the mannerism of prewar photography and held eight annual exhibitions with Western photographers whose work expressed social commitment. These included Margaret Bourke-White, W. Eugene Smith, Henri Cartier-Bresson, and Bill Brandt.

Domon combined social documentary with a refined formal record of classical Japanese art. This dual task of advocating avant-garde realism while reasserting classicism was part of a peculiarly Japanese dilemma and was the source of great creative vitality. Between 1940 and 1954 Domon photographed Muroji, a Buddhist temple close to the Muro River near Nara. On the banks of the river he photographed the giant figure of Miroku carved in the rock. Inside the temple he photographed the sculpture, including tenth-century Heian carving. He isolated the details of the limbs and the expressive hand gestures, characteristically emphasizing the grain and texture of the sculpture. With the same strategy that he applied to the sculpture, he recorded the horrifying scars of Hiroshima. His book *Hiroshima* (1958) contains explicit photographs of the victims, their scar tissue and skin grafts, and detailed photographs of surgery. The book, with its jacket by Joan Miró, is addressed to the world. It is a universal statement with a hint of survival beyond the appalling scars. Domon's Hiroshima work was included with Shomei Tomatsu's photographs of Nagasaki in the *Hiroshima–Nagasaki Document* (1961). Domon continued to produce a number of books on classical Japanese art and returned to Hiroshima to continue his document of the survivors in *Living Hiroshima* (1978).

Domon's realism was the appropriate method for the time and the events. At a point of national disintegration, the order of an objective realism, with its implied detachment, was the only possible discipline. In response to the atrocious events of history, the pursuit of artistic expression seems almost obscene. At the center of the catastrophe, literally, in the rubble of Hiroshima, there is no distance from which one can accommodate the significance of the event, let alone express it artistically. The reality is so appalling that no language is capable of describing it. After the first atomic test at Los Alamos, New Mexico, J. Robert Oppenheimer referred to "the sun brighter than a thousand suns," reflecting a phrase from the Bhagavad Gita. The vocabulary of archetypal myth was required to

SHOMEI TOMATSU, NAGASAKI, 1961

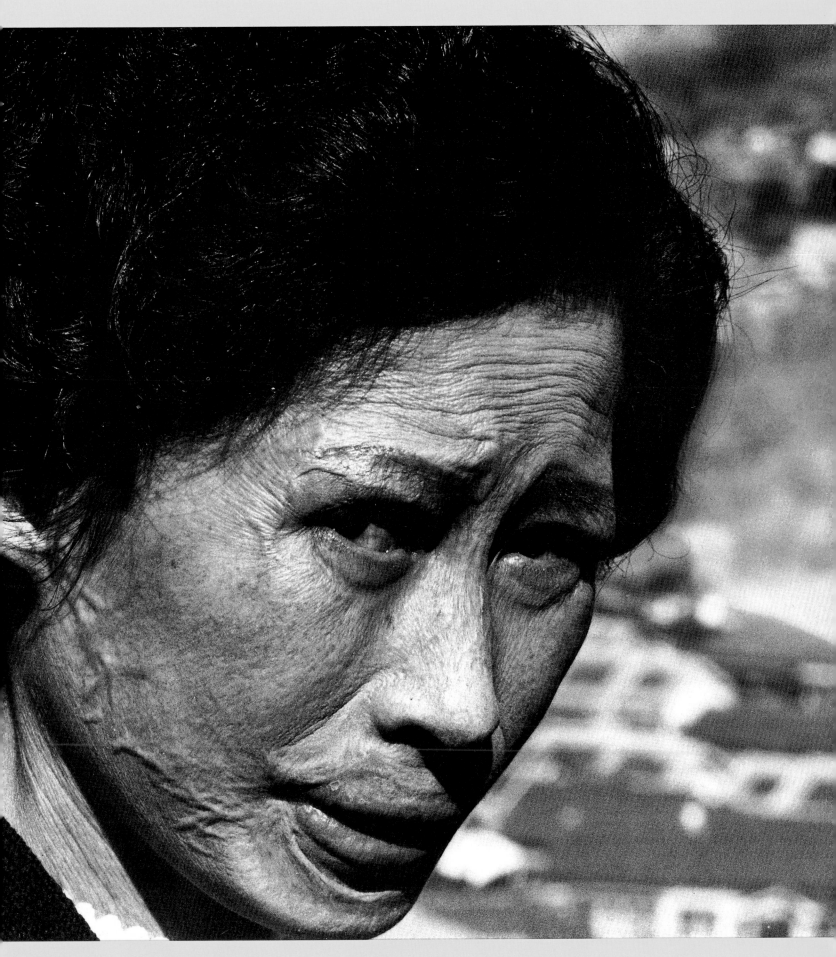

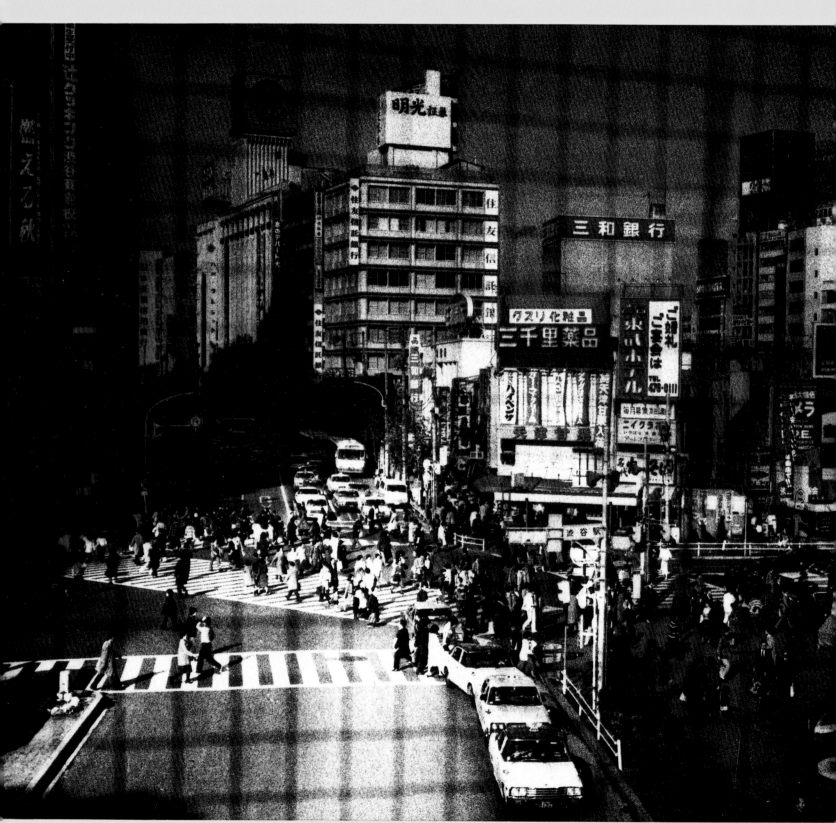

DAIDO MORIYAMA, FROM *HIKARI TO KAGE (LIGHT AND SHADOW)*, TOKYO, 1982

accommodate a concept that eluded the descriptive power of words. Words trailed reality as an approximate shadow of truth.

The consequences of the events in Europe between Hitler's pact with Stalin in 1939 and the fall of Berlin and the Soviet occupation of Warsaw in 1945 had heralded a nihilism prophesied so accurately by Dostoevsky a century before. European culture had become a question mark suspended in existentialist observation. Writing at the beginning of this decade in his lecture *Ruins and Poetry*, Czeslaw Milosz described the effect of this upheaval of European values on Polish poetry. He quotes the German philosopher Adorno, who said that after the Holocaust poetry was impossible. In response to the ruins of Warsaw and the betrayal those ruins symbolized, a fragmented language emerged, sometimes decades later. It was a language of details and observation rather than historical polemic, which remains the vocabulary of propagandists. The details and the particulars are the constituents of so much photographic experience. Wristwatches, glasses, and crucifixes are frequently the signs of humanity in the mire of information we have received from photographs of war since 1939. Behind what Milosz describes as the "fragility" of civilization, he writes that "man constructs poetry out of the remnants found in ruins."

Myth, which was a surrogate history in prewar Japan, was challenged and the emperor's divinity overthrown. Food, shelter, blankets, and medical supplies were the immediate needs; mythical concepts had already been betrayed. The emperor had uttered the unthinkable, and in a trance the people of Japan had accepted the unacceptable—surrender—like a nation brought back from the brink of collective suicide. Photography, especially that of Domon, recorded the scar tissue and the surgery that constituted the details and the fragments like Milosz's "remnants" against a backdrop of ruins. By preserving the objectivity of his intentions through the mechanics of the camera, Domon consciously distanced himself from subjective indulgence, but also from the expressive intentions that lie at the heart of so much artistic ambition. The power of Domon's work has nothing to do with artfulness: it fulfills the duty of witness and establishes a legacy of evidence. These are the concerns shared by those writers looking back to their experiences in the Warsaw Uprising or the ghetto.

As Japanese housing was reestablished, the public transport system started to run again, and rice came in from the countryside, another language was required to describe the wounds and transformations to which the nation was subject. The objectivity of Domon's work, its strength in the face of the enormity of events, would become its limitation. There was a need to express another experience, one born out of the Oc-

cupation rather than bombs. A young generation of artists and photographers was growing into adulthood and maturing among the ruins. They had lost their childhoods and sometimes their families in the war, and they needed a form to express that loss and to help them search for their confused origins. A mythical vocabulary might accommodate the events of 1945. Those events were so profoundly disturbing that only myth could encompass them. The myth would be dark and full of shadows like those found scorched on the stone and brickwork of Hiroshima. At the epicenter of the Hiroshima explosion a man was painting a wall. He disintegrated while perched on a ladder with his arm outstretched. His silhouette remains. He was severed from his shadow as the atom was split. The shadow continues to paint the wall, which inconceivably still stands. There are myths of shadowless men, like ghosts, who permanently accuse their murderers.

JUNIN-NO-ME

WHEN Toyo Miyatake was sent to Manzanar Camp in California, Yasuhiro Ishimoto, a young student of Japanese descent who had been born in San Francisco, was relocated to a camp in Amach, Colorado, where he studied photography. In 1952 Ishimoto graduated from the Institute of Design in Chicago, where he had studied under Harry Callahan and Aaron Siskind. The following year he went to Japan. Ishimoto had already established a reputation among younger Japanese photographers for his beach photographs from 1950, which revealed a distinctly Western influence, and for his photographs that Edward Steichen had selected for exhibition at the National Museum of Modern Art in Tokyo. Ishimoto's arrival affected the course of photography in Japan during the critical decade of the fifties. A young generation, hungry for a view outside Japan and for a new form of photography, saw Ishimoto as an example of greater expressive potential than the realists of the Shudan group, who were engaged in documenting street life, destitution, and the socially displaced. Just as the Shudan group had exposed the Japanese to major bodies of work by foreign photographers, Ishimoto offered Japanese photographers a perspective nurtured by the Western influence of the Chicago Institute of Design. Material was arriving in Japan with which the pattern of imitation, absorption, and reinterpretation could be established. Ishimoto was returning to the visual core of his homeland

and rediscovering Oriental form.

Walter Gropius at the Bauhaus had described Japan as a basic design course. Ishimoto came out of Moholy-Nagy's New Bauhaus in Chicago, which had the original intention of producing "universal designers." In 1953 and 1954 Ishimoto photographed the Katsura Palace in Kyoto, the most refined example of Japanese seventeenth-century architecture belonging to the imperial household. The palace combined the modesty of an aesthetic influenced by the spareness of the tea ceremony with the elegance of imperial style. Ishimoto's photographs explored the asymmetrical architectural patterns and reinforced an intense focus on the grain of the wood floors and pillars, the texture of the stepping stones and the moss on the pathways. Ishimoto reasserted a Japanese sensibility, an almost tactile sense of surface.

In spring 1956 two exhibitions organized by Tatsuo Fukushima in Tokyo signaled a new era. They elicited a response from Ken Domon that the realist period of objective documentary was over and a period of "subjective documentary" was born. At Matsuya department store, Ikko Narahara's exhibition *Man and Land* compared two isolated communities: a small village in Kyushu destroyed by lava from the Sakurajima volcano, and a coal-mining island, built of concrete, south of Kyushu. One community was destroyed by natural forces; the other was founded on human need and was both artificial and barren. Narahara constructed an argument by suggestion and juxtaposition rather than objective compilation of evidence.

The second exhibition was a photo story, *An American Girl in Tokyo*, by Eikoh Hosoe, held at the Konishiroku Gallery. The narrative described Hosoe's friendship with a girl on an American base that he visited in order to study English. Hosoe was eager not only to improve his English but to bridge a gap and develop an emotional relationship with someone from the West. He was aware of the fictional quality of this relationship, which was taken up by a Japanese radio station and dramatized. The sense of narrative, in this case an almost diaristic sequence, was to become a significant characteristic of Hosoe's work, giving it a cinematic or theatrical quality. Hosoe's sense of theater enabled him to transcend the documentary ethic that had dominated his photographic education. *An American Girl in Tokyo* clearly reflected the hunger for new relationships, for a world of bonds rather than a cleavage between the occupiers and the occupied. It was twelve years since the surrender, and the climate was right for a new form reflecting reorientation, not disintegration.

The two exhibitions emphasized more than a shift in style. They were assertive statements of independence from the realist convention. The Magnum group founded in 1947 by Robert

Capa, David Seymour, Henri Cartier-Bresson, George Rodger, and William Vandivert indicated the growth of a new photojournalism in the West and inspired Tatsuo Fukushima, the critic, to establish the group Junin-no-Me (The Eyes of Ten) in 1956 shortly after the two seminal shows. Besides Yasuhiro Ishimoto, Ikko Narahara, and Eikoh Hosoe, the group consisted of Shome Tomatsu, a young photographer from Nagoya with a reputation for his photojournalistic style; Kikuji Kawada, an economics student from Rikkyo University who had developed a form of reportage described as "symbolic"; Masaya Nakamura; Akira Tanno; Akira Sato; Shun Kawahara; and a young woman, Toyoko Tokiwa. Although the work of the photographers varied in style, they were of the same generation, mostly in their late twenties, and they stimulated each other by their diversity. They held their first group show in 1957 at the Konishiroku Gallery and their last show in 1959. Junin-no-Me was then transformed from a group with a common interest to a professional agency called Vivo, which included Tomatsu, Hosoe, Kawada, Narahara, Sato, and Tanno.

By the end of the decade the figures who would vitalize the artistic environment of Tokyo in the volatile sixties were already in the city establishing their direction and style. Junin-no-Me and Vivo were the foundations for those photographers who would fully develop in the invigorating atmosphere of the new decade. Economic recovery coincided with an assertive artistic strategy. Theater, dance, cinema, and graphics reinforced an essential Japanese style. The transition from imitation and absorption to Japanization was about to take place. The new generation of photographers had become adult in a climate of defeat. The war had stolen their childhood. With rising national prosperity, the time was approaching when they could recover their origins.

Living in Tokyo among the community of artists in the fifties was the young dancer Tatsumi Hijikata. In 1957 Akira Kurosawa's film *Yoidore Tenshi* (*The Drunken Angel*), starring Toshiro Mifune, made a great impression on Hijikata for its portrayal of life in the Tokyo dance halls frequented by the American troops. Hijikata was so impressed by the Mifune character that once a week he would dress in a white suit and grease back his hair, then, with his meager funds earned from working in a laundry pay to dance with girls in a Gotanda dance hall catering mostly to American officers under the control of the Military Police. Hijikata's adoption of the Mifune role and his subsequent humiliation as the Japanese women offered their services to the foreign troops further emphasized that Hijikata's starting point as an artist, like that of his contemporaries, was a total loss of identity.

In 1959 Hijikata visited the writer Yukio

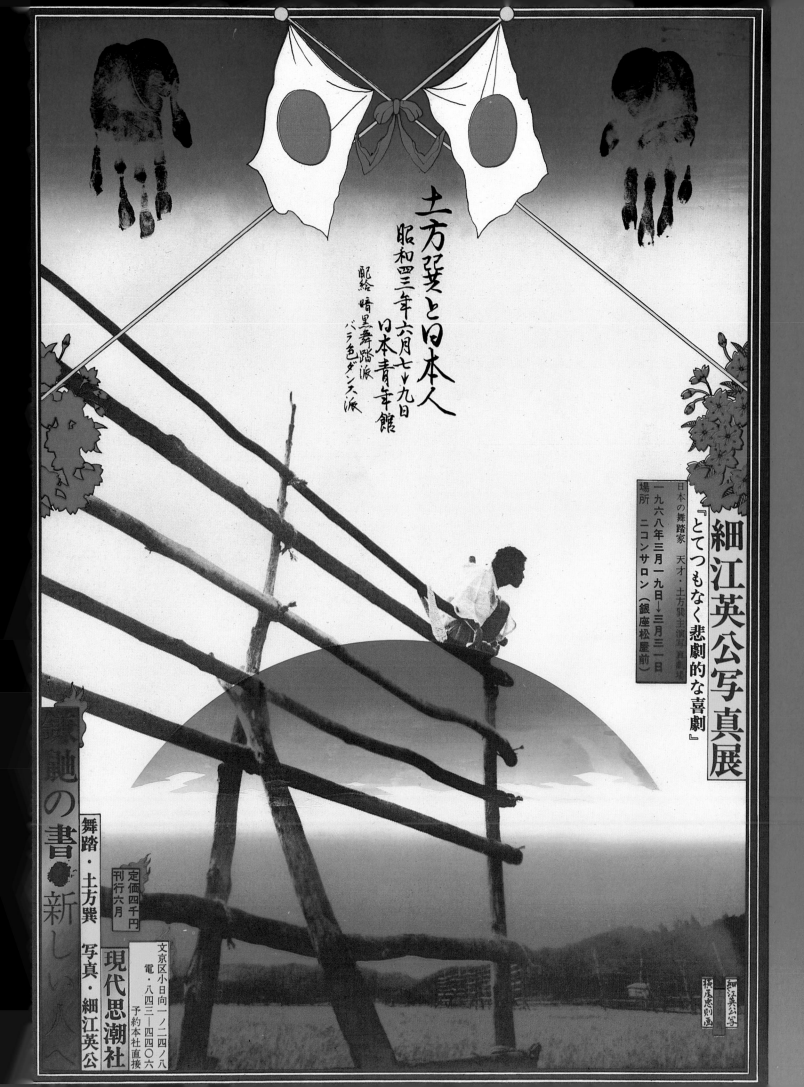

Mishima to gain his permission to perform his own dance adaptation of Mishima's novel *Kinjiki* (*Forbidden Colors*). Mishima admired Hijikata's audacity and honesty in seeking what amounted to his patronage. Hijikata was also aware of a fundamental split that distinguished him from Mishima but also served as the source of his attraction to the writer. Hijikata came from a family of noodle manufacturers in Akita in the far north, not from a sophisticated Tokyo salon. He still regarded himself as a "man of the body" who was confronting the superior cerebral qualities of the writer. Mishima, however, was trying to balance his work as a writer with the cultivation of the body. He was obsessed with the inadequacy of language and with transforming his flesh. Hijikata later took great pride in returning to his core identity as a "man of the body," the founder of a new form of dance, *Butoh*, which exercised the focus of the mind while making incredible demands on the body. To a British theater director who asked, "What is the philosophy behind *Butoh*?," Hijikata replied, "There is no philosophy before *Butoh*. It is only possible that a philosophy may come out of *Butoh*."

Hijikata performed *Kinjiki* in 1959 at the Dai-ichiseimei Hall in Tokyo, which held only six hundred and fifty people (later Hijikata's studio was called Dance Experience—650 in reference to the hall). It was a shocking performance in which Hijikata slaughtered a chicken on a stage splattered with blood. Members of the audience fainted, Hijikata was outlawed as a dangerous dancer, Mishima was thrilled, and Eikoh Hosoe was so impressed that he went backstage to introduce himself to the dancer.

Hosoe had learned about dance through the performances held in the fifties at the American Cultural Center in Tokyo and through Akiko Motofuji, a dancer in Fukushima's Democrat group. He had never witnessed such an intense performance as Hijikata's and offered to photograph him. Hosoe's photographs of Hijikata and his dancers were exhibited the following year at the Geiko Gallery in Tokyo. Mishima wrote a short introduction to the catalogue describing Hijikata's performance as a "heretical ceremony" in which classicism and the avant-garde were fused in a symbolic language. The statement reflected Mishima's own role as patron of the avant-garde and defender of classical values. In addition to Hijikata, Mishima offered support to Shuji Terayama, the poet and theater director. While endorsing these new creative forces, Mishima asserted the conventions of Japanese literature. His *Modern Noh Plays* exemplified his innovative sense of tradition, resulting in a true modernism. The marriage of classicism and the avant-garde was at the center of the Japanese motion that alternated so explicitly between past and future.

Before the Vivo photographers split up in 1961 to follow their separate directions, vital connections had been established. Shomei Tomatsu

held his first exhibition at the Fuji Photo Salon in 1959. It was called *The Japanese*. The sense of identity was emphasized. The previous year the Japan Photo Critics Association had awarded him a prize as most promising photographer, and in 1959 he received another major award from Mainichi. In 1961 Tomatsu was working with the film director Nagisa Oshima on the adaptation of Kenzaburo Oe's celebrated novel *Shiiku* (*The Catch*), which had won the Akutagawa Prize in 1958. Hosoe continued to collaborate with Hijikata. In the summer of 1960 he made a twenty-minute film on a beach in Chiba Prefecture with the dancer emerging from the sea to steal the navel of a child. The film, *Navel and Atomic Bomb*, was a mythical dance-drama composed of a cycle of symbols of birth and atomic destruction.

Tokyo in 1960 was dominated by jazz following a visit by Art Blakey. The jazz period brought together a number of artists who shared enthusiasm for the music. Hosoe's film included music by the jazz pianist Norio Maeda and was shown during the wave of jazz with Shintaro Tanigawa's film *X* and Shuji Terayama's *Catology*. The latter brought outcries as Terayama had filmed the death plunge of a cat he hurled from a high building. Terayama was already closely involved in experiments with Hijikata.

Hosoe published his first book, *Man and Woman*, in 1961. He returned with Hijikata to the same beach in Chiba to develop a series of nudes called *Embrace*. That year he saw Bill Brandt's beach nudes for the first time and abandoned the work with Hijikata for fear of imitating Brandt. It was not until nearly ten years later that he revived the series in the studio. In the summer of 1960 Hosoe had received a call from Mishima's publishers asking him to take some portraits of the writer for a forthcoming book of his critical essays. When he met Mishima, Hosoe asked him why he had been chosen for the assignment and Mishima replied that he had greatly admired Hosoe's photographs of Hijikata. Mishima wanted to be photographed as a "man of the body." He offered himself as Hosoe's subject matter.

At their first meeting Mishima was seated half naked in his garden, wearing sunglasses that he did not remove when introduced. His father was watering the garden. In an inspired move Hosoe grabbed the hose and wrapped Mishima in it as he lay across a mosaic zodiac, a feature of his baroque environment. Mishima approved of these unusual portraits and asked Hosoe what he was trying to achieve. Hosoe answered that he was interested in the "destruction of a myth," in penetrating the facade of the successful writer. Hosoe wanted to create an interior document, not a publicity shot. Mishima roared with laughter and later allowed Hosoe to

come back and continue to develop a series. They worked together for several months to produce *Barakei* (*Killed by Roses*) the document of a private theater on Mishima's own imaginative territory. In offering himself as subject matter Mishima was adopting a subservient, almost masochistic role, allowing Hosoe an unprecedented directorial authority. The resulting book established Hosoe internationally, but its full significance would not be apparent for another decade.

In 1961 Kikuji Kawada, another former member of Junin-no-Me, exhibited a series called *Chizu* (*The Map*). He combined photographs of memorabilia of the Special Attack Corps (kamikaze) from the museum at Etajima with photographs of the ceiling of the atomic dome at Hiroshima. Portraits of the youthful pilots, imperial insignia, tattered uniforms, farewell letters, and a crumpled flag of the rising sun were astonishingly juxtaposed with the abstracted patterns the radiation had etched into the concrete of the dome. Even in this structure, a symbol of atomic destruction, Kawada reflected the sensibility that Ishimoto had revealed so delicately when he photographed the elegant patterns of the seventeeth-century Katsura Palace. In the book *Chizu* (1965) the radiated surfaces of the dome were presented as the outer pages of gatefolds that opened to reveal the memorabilia within. The juxtaposition of abstraction and symbol was as direct as the convention of the book could allow. Scattered among the military insignia were photographs of billboards, Coca-Cola signs, and discarded packs of Lucky Strike. Kawada's *Chizu* is a chart back to the emblems that constituted Japanese imperial history, displaced by the signs of a new occupied state, the consumerist remnants of a different kind of invasion. The fragments signaled both a sense of history and the immediacy of the present. In the cracked concrete Kawada traced the lines of his native identity. In the introduction to *Chizu*, the novelist Kenzaburo Oe quoted W. H. Auden.:

Here war is simple like a monument;
a telephone is speaking to a man;
flags on a map assert that troops were sent;
a boy brings milk in bowls, there is a plan

for living men in terror of their lives,
who thirst at nine who were to thirst at noon,
and can be lost and are, and miss their wives,
and unlike an idea, can die too soon.

but ideas can be true although men die,
and we can watch a thousand faces
made active by one lie:
and maps really point to places
where life is evil now:
Nanking; Dachau.

The qualities that made Kawada's map peculiarly Japanese also elevated the national to the universal.

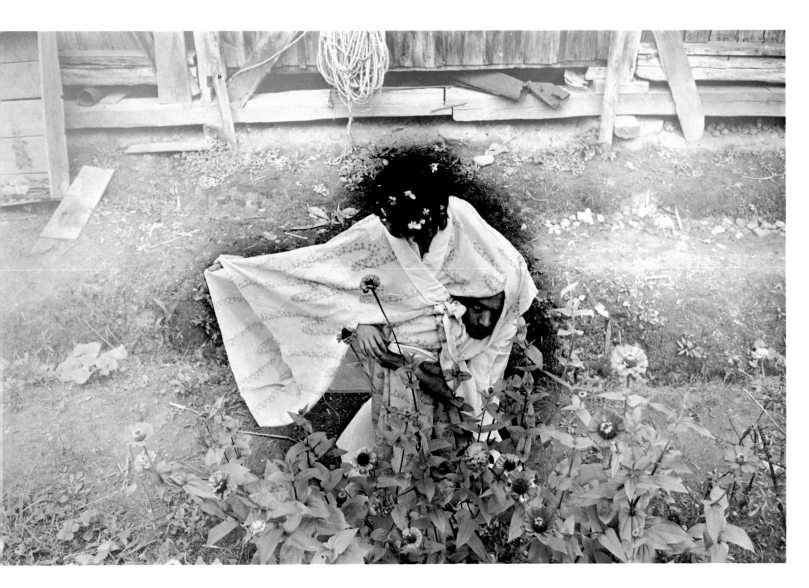

細江英公

**EIKOH
HOSOE**

It is said that the history of maps is actually older than that of literature. Even in prehistory, man had to make graphic representations in order to understand where he was and how far he had to go. If the territory depicted in the diagram can be tread upon by human feet, it belongs to history. If it cannot be so tread upon, if it is an imaginary garden room, or the wilderness of human relationships or the warm intimacy of the human body, then it belongs to the realm of drama. Just as a map may be read in many ways and give rise to many chance encounters, so too the text is a guiding plan that enables us to move back and forth between "interior" and "exterior" geography.

SHUJI TERAYAMA, 1975

17

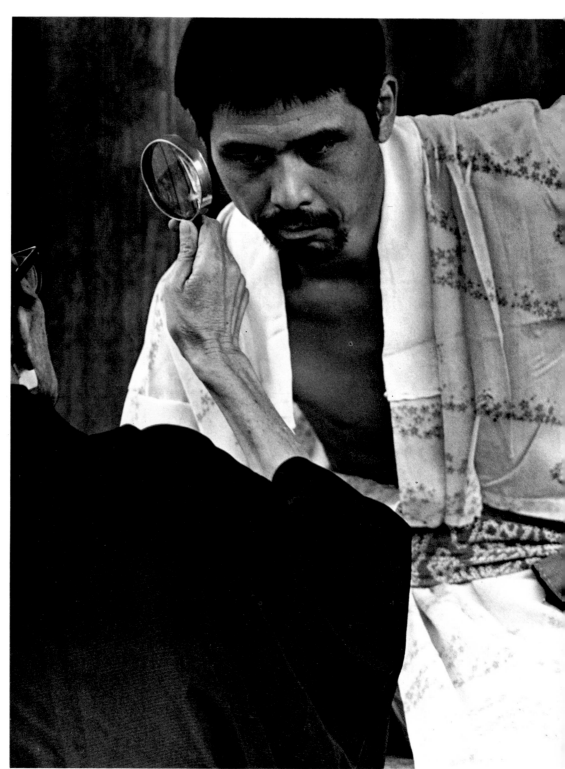

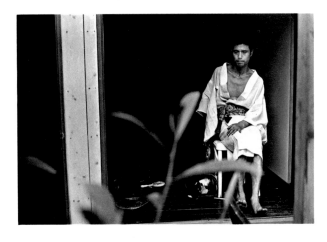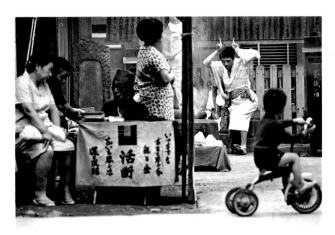

THE DEMON MYTH: KAMAITACHI

A legend still exists in country districts of Japan concerning the demon called Kamaitachi—a weasel that haunts the rice fields. The demon is said to slash his victims as if with razors. Eikoh Hosoe learned of this myth from the farmers in the far north when in 1944, as an eleven-year-old child, he was evacuated from Tokyo. The demonic imagery of Kamaitachi became linked in his mind with the terrible events of the final war years. The myth provided a language with which he could touch the trauma of the past with the imagination of a child. Through his photographic recreation of the legend, Hosoe explored his personal history against the backdrop of national catastrophe.

In September 1945, shortly after the surrender, Eikoh Hosoe, who was twelve years old, returned to Ueno Station in Tokyo. He had traveled back with his mother and four-year-old brother from Tohoku in northern Japan. It was late at night and there was no transport from Ueno, so they huddled in a group on the floor by the station toilets. The station was packed with travelers returning from the far corners of Japan.

Very early the next morning, with his brother on his back, Eikoh and his mother took a tram home. It was remarkable that any transport was working. Through the window of the tram Eikoh saw the ruins. His father, a priest, had stayed at his Shinto shrine throughout the war. Every week he would send a letter from Tokyo to the remote farming village where his wife and children had been evacuated in 1944. His letters included drawings, colored in red and black, of the air battles over Japan, the B-29s approaching and the intercepting Zero fighters crashing to the ground. The backgrounds were often so bright a red that the night raids looked like daytime. In Tokyo Eikoh read in a newspaper about a "special bomb" and heard people mention Hiroshima and Nagasaki. The word "special" seemed very mysterious.

After he had settled at home Eikoh wandered to a place where the landscape spread before him. He crossed a bridge

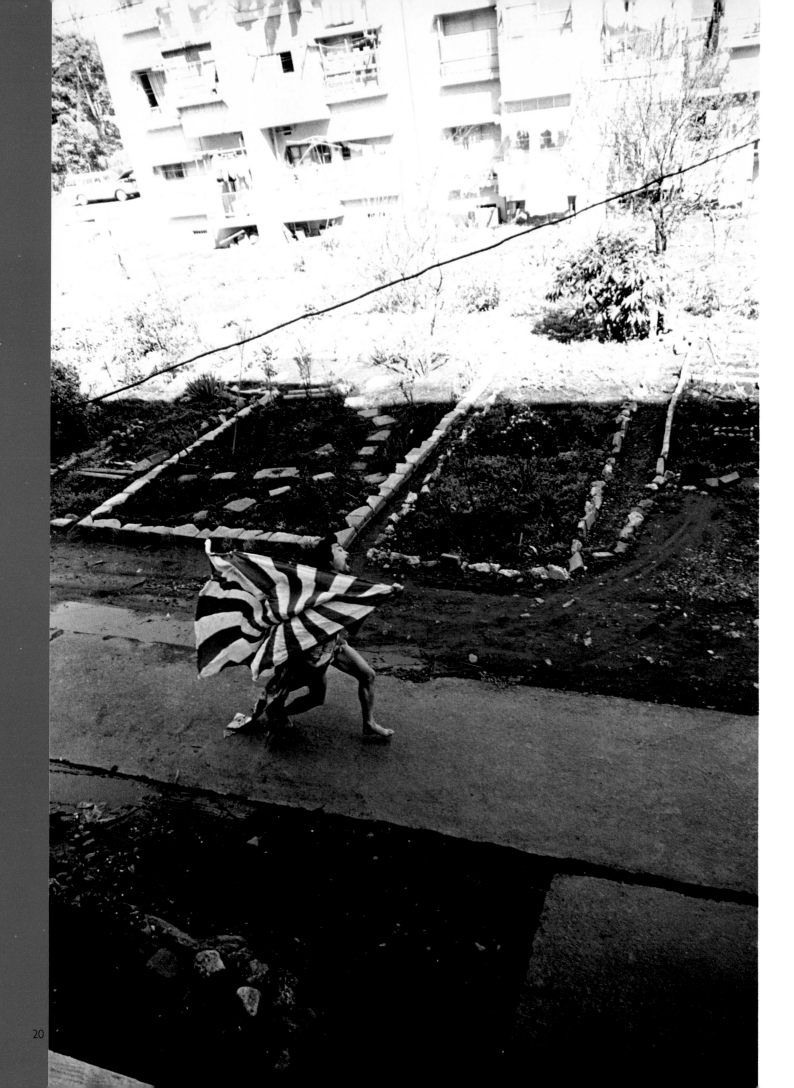

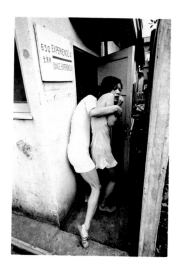 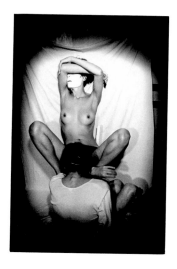 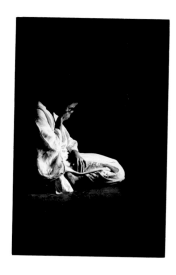

and kept walking. Most of the houses were ruined and had been torn down. New huts were being built, and people were living under simple boards as shelter from the rain. American jeeps and trucks were noisily tearing about in the mud.

One day soon after Eikoh's return a plane flew low over his school. He could actually see the American pilot in the cockpit. The pilot's face seemed very red. The children tried to throw stones at the plane.

By early October there was a simple transport system throughout the city. Crude shelters had been built. People went out to the country to buy rice and vegetables, even though rice distribution was closely controlled by the police. Schools were functioning and new curricula were being established. The speed of recovery was as remarkable as the devastation. By 1947 Hosoe had acquired a camera and began to process film. He watched his father in the darkroom, then taught himself to print. A year later he hung his first photographs in his classroom. They were of American cars and car radios. While he was furthering his language studies through his American contacts, Hosoe also photographed inside an American base. One of these photographs gained him a big prize from the Fuji Film Company, and he decided to become a photographer.

As a student in the early fifties Hosoe had explored the downtown areas of Asakusa, photographing the lowlife of the prostitutes in the small bars and on the Azumabashi Bridge. The photographs were intended as realist documents in the style of the Shudan group, but Hosoe was also exposed to a wide group of artists through Fukushima's Democrat. When he graduated from Tokyo College of Photography in 1954 Hosoe immediately decided to become a freelance photographer. He took on any work he could find, and an editor asked him to produce a book about 35mm photography, which was published in 1955. With the

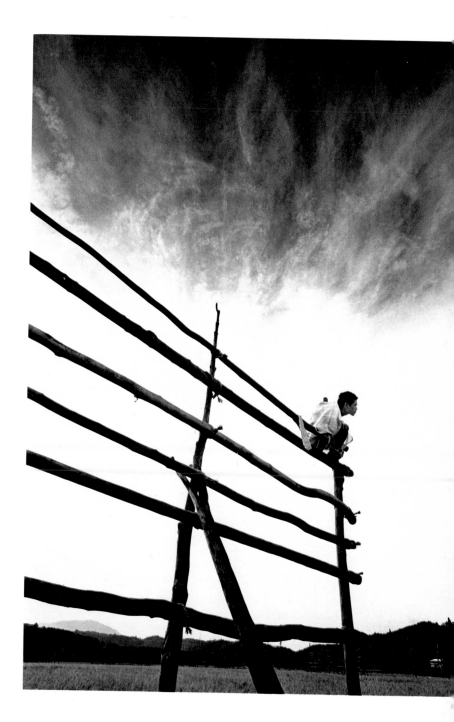

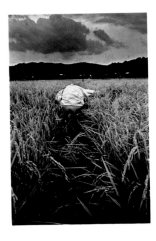

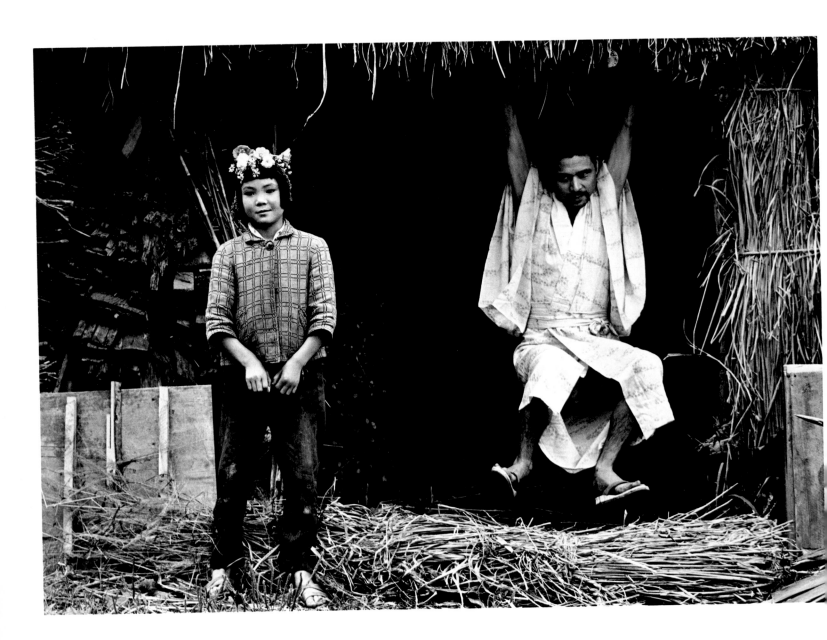

 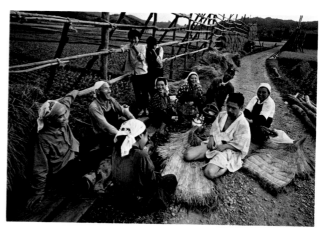

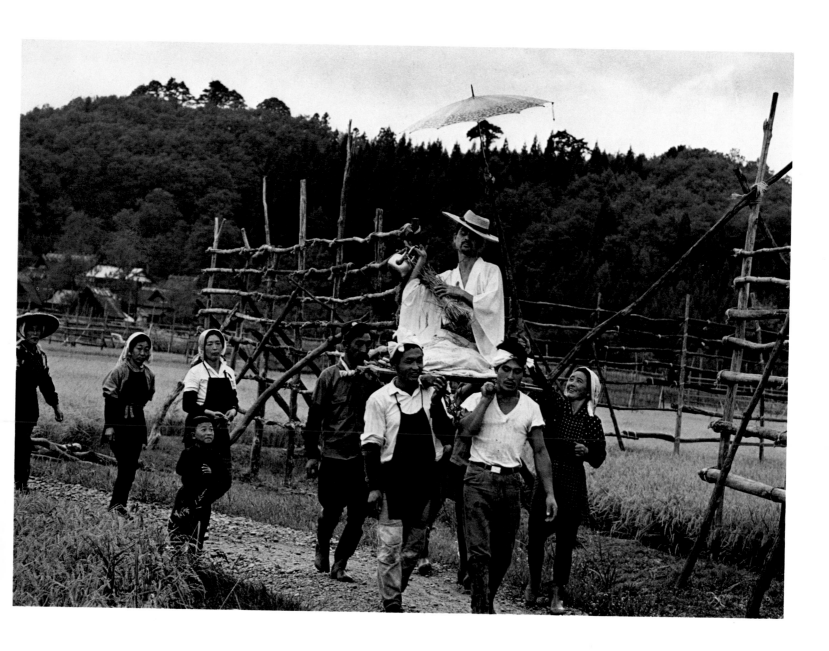

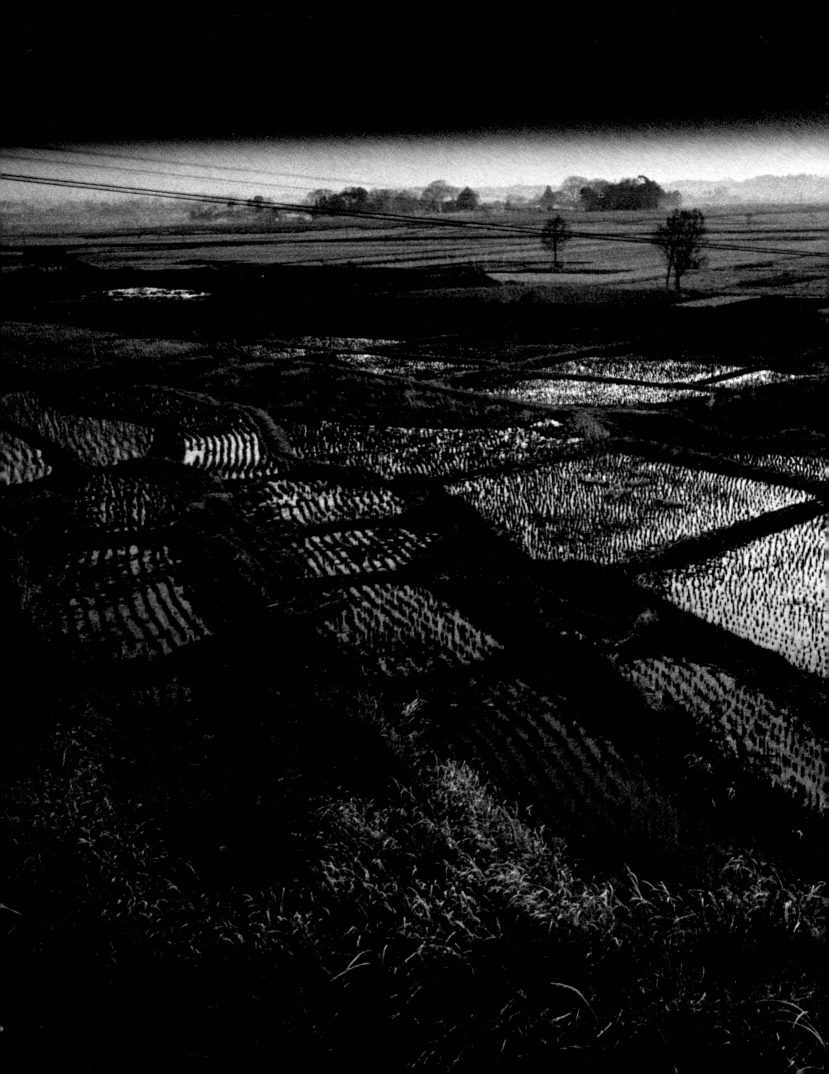

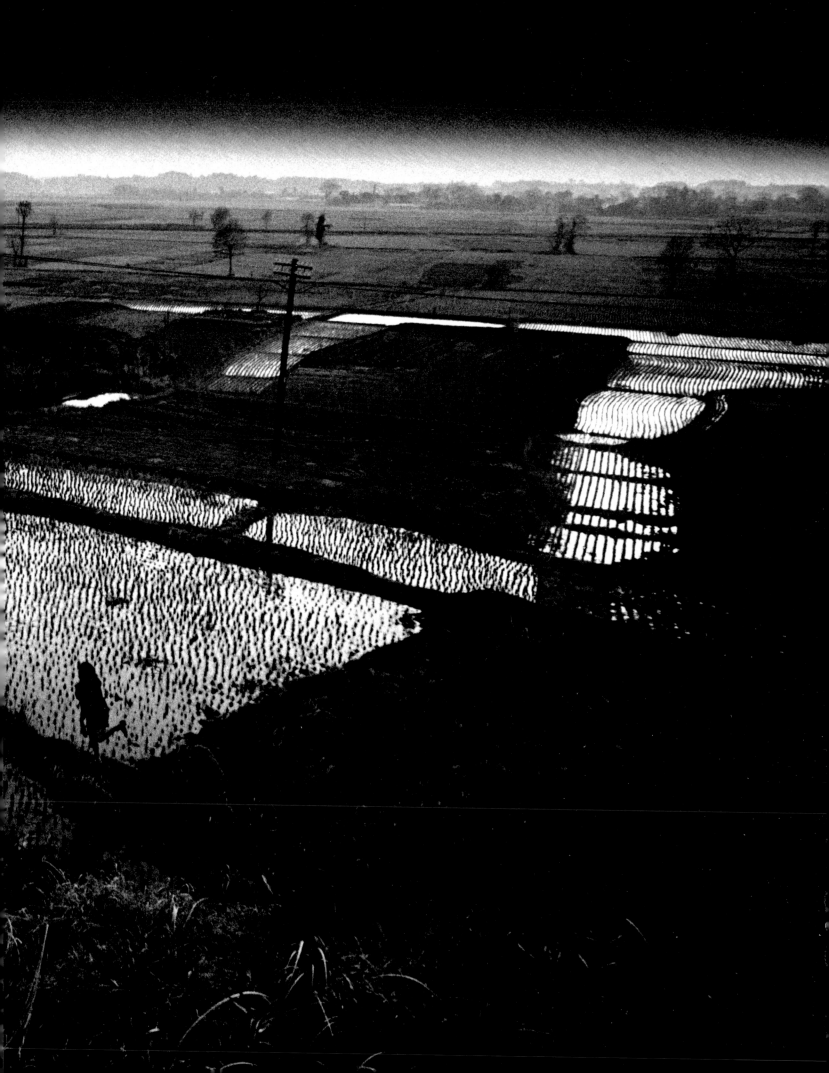

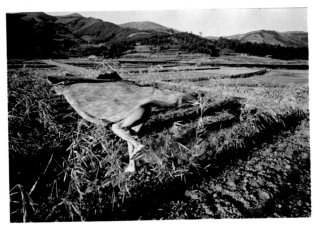

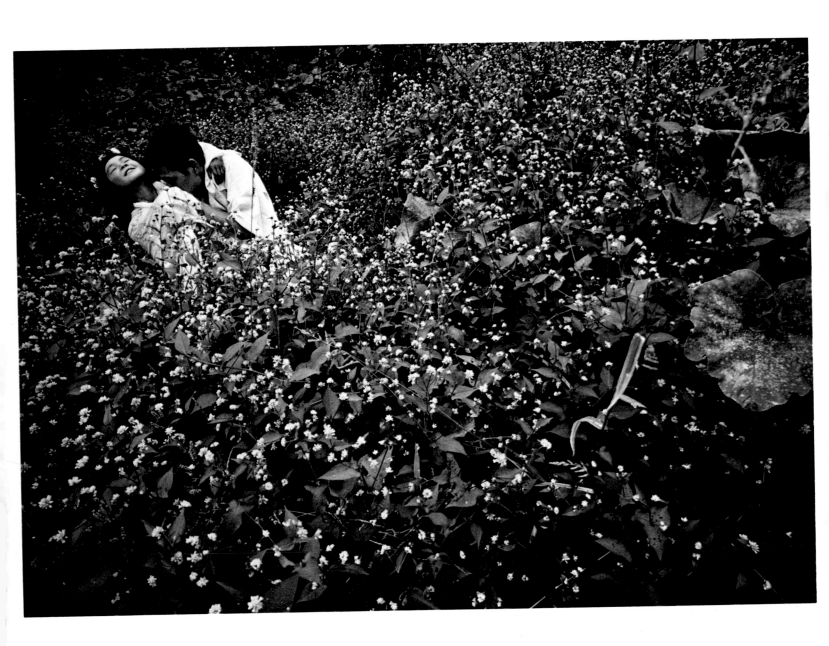

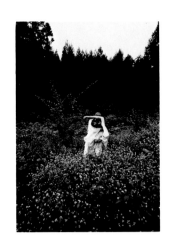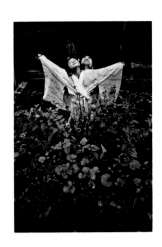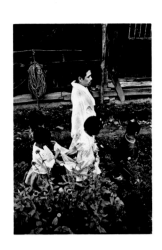

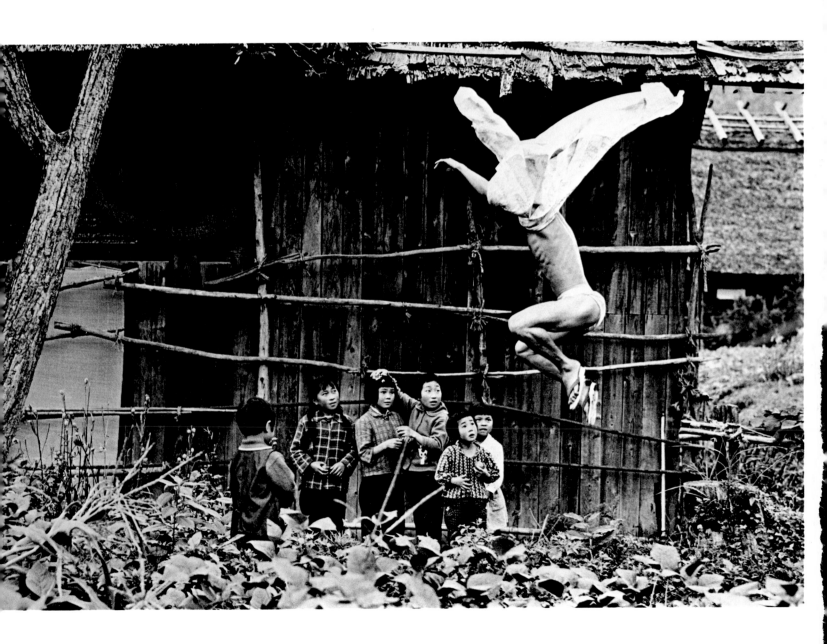

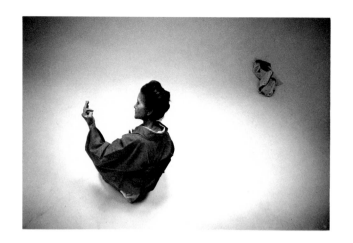

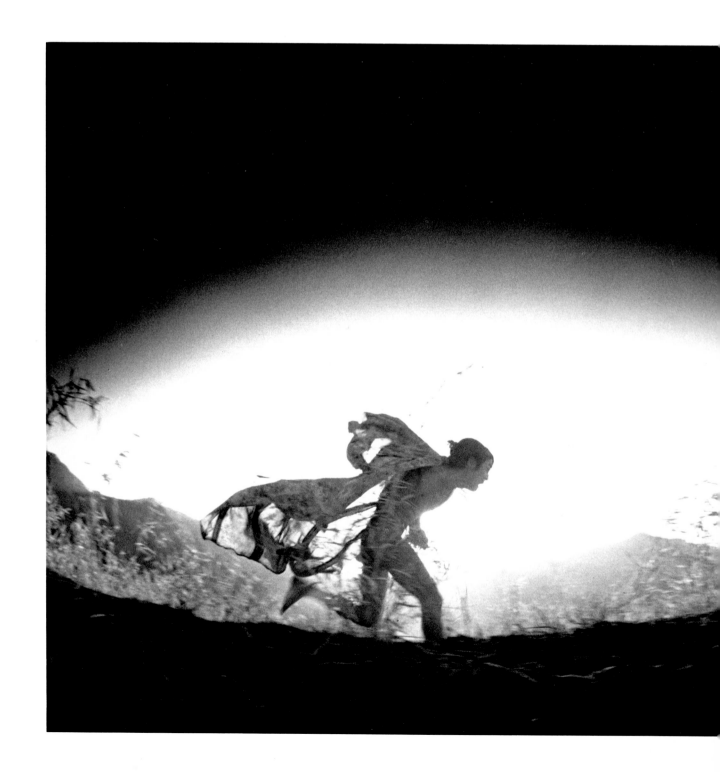

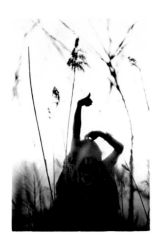

money from the book Hosoe set out to explore Japan for the first time. He traveled through Kansai, the island of Shikoku, and the southern island, Kyushu. The journey was the first step into a metaphorical search for his identity. He returned with negatives and a sense of the islands from north to south. It was ten years since his arrival as a child at Ueno terminal.

Following the publication of *Barakei* in 1963 Hosoe spent three years traveling extensively outside Japan. After this expansive period abroad he returned and revived his work with Hijikata. Together they traveled to the north of Japan, where Hijikata was born and brought up, to create *Kamaitachi* as a dance-drama. Hosoe was returning to his memory of 1944 with a narrative that was both mythical and autobiographical. *Kamaitachi* involved a return to an interior map that Hosoe and Hijikata shared. They visited Hijikata's birthplace, then traveled by car through the mountains to a neighboring village. As they drove through a mountain pass, a great plain of rice fields opened up before them. It was a scene that Hosoe recognized from his early memories, and they began to shoot. Their work became a series of spontaneous happenings. As they proceeded through the villages they would involve the farmers, even asking them to carry Hijikata as if there was a village festival. When asked what they were doing, they would tell the villagers that they were working for television, because television still had a magical power for the country people. Later they would return and offer the villagers sake in apology for their deception.

The thirty-seven prints in the *Kamaitachi* series depart from photographic tradition: they are bleached, cinematic, and intensely dramatic. The drama is of possession, not exorcism. At the start the dancer appears in the village as the Fool, the innocent, but at the end he carries off a small child. The farmers laugh at the Fool, who entices the children with his mysterious leaps. The possession is allied to the force of adolescent sexuality, just as Kamaitachi is linked to the spirit of the soil and fertility. The dancer seduces the girls in the fields and broods under the spell of his possession

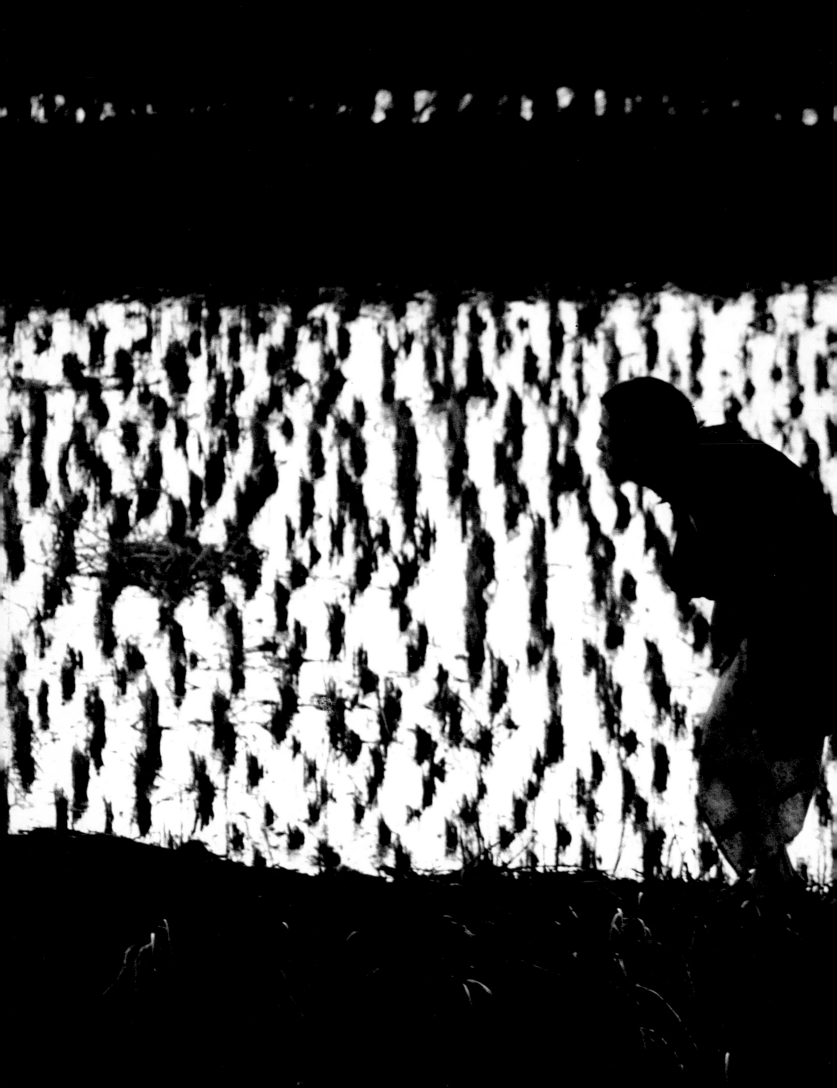

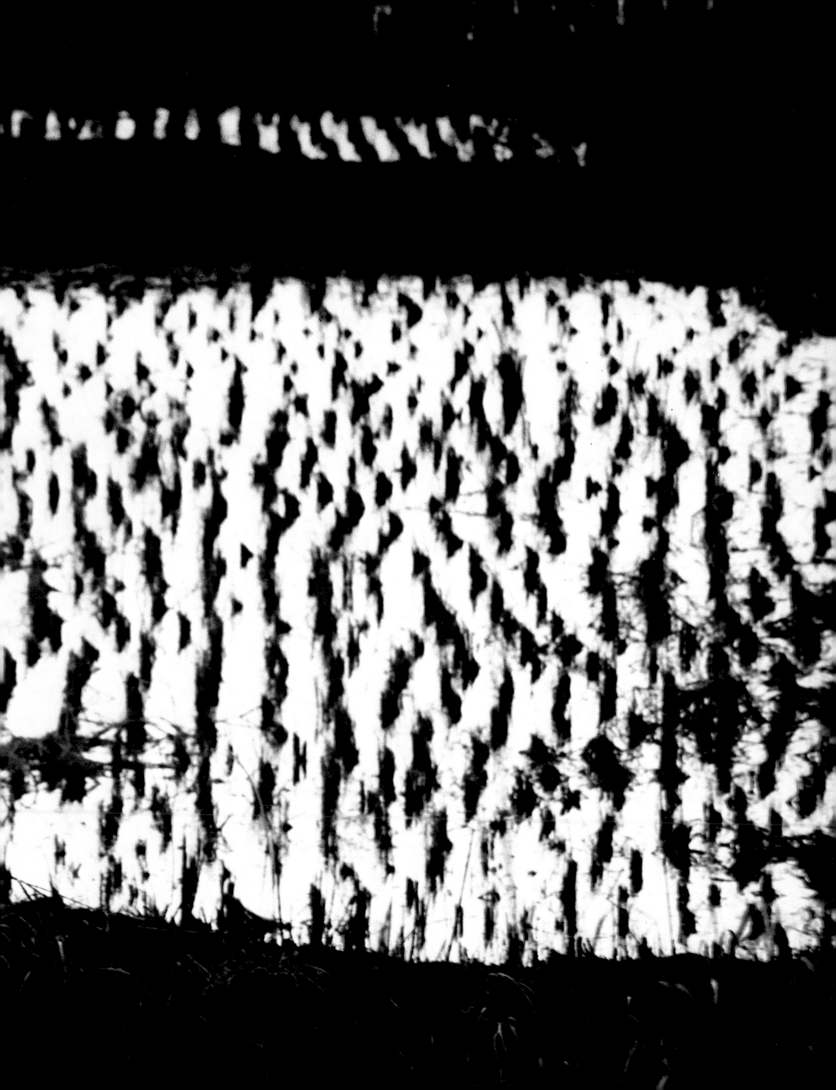

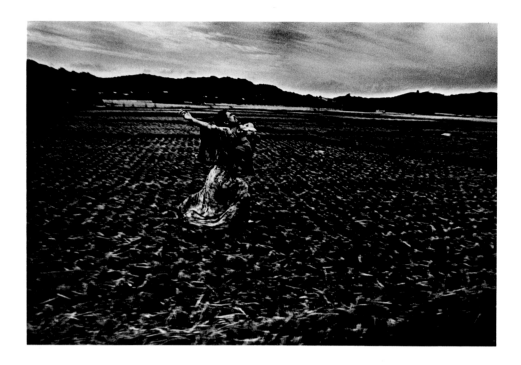

beneath a darkening sky. There is a great landscape view, across which a small figure is running as the black sky descends. Apart from the telegraph wires it is a timeless scene, but its implication is specific. A popular Japanese encyclopedia defines *kamaitachi* as "a lacerated wound caused by a state of vacuum which is produced partially in the air, owing to a small whirlwind." Hosoe has developed an autobiography of fear. The demon beneath the falling sky is an appropriate image for an eleven-year-old imagination on the run from incendiary bombs. *Kamaitachi* is also the first breeze of a nuclear age. The series ends in total darkness, a premonition of a black sun over 1945.

Kamaitachi was exhibited at the Nikon Salon in Tokyo in 1969 and was published at the same time in a book designed by Ikko Tanaka. Another leading designer, Tadanori Yokoo, produced a poster for the exhibition and the publication. Yokoo colored the image of the dancer brooding on the fence where the rice straw was dried and inserted two Japanese flags, reinforcing the drama with emblems of national as well as personal identity. In the late sixties Yokoo designed many of the posters for Hijikata's dance group, Ankoku Butoh-Ha (Black Dance Theater), as he did for Terayama's Tenjosajiki (Laboratory of Theater Play). Yokoo used a method of coloring reminiscent of Ukiyo-e woodblock tradition with tinges of psychedelic intensity. Mishima provided the calligraphy for some of these designs. For *Kamaitachi* Hijikata dipped his hands in gold ink and stamped each poster with the imprints of his palms. Every

stage of this production was ritualized. Hijikata danced in the gallery where the photographs were exhibited. The fusion of dance, graphics, and photography was at once innovative and retrospective. The economic confidence of the nation, only a year before the great Osaka Expo, coincided with an artistic climate that made such a fusion not only possible but essential in determining a course of true identity.

There is a sequel to *Kamaitachi*. It begins in Tokyo after Hosoe's return in 1945. The series is called *Simon: A Private Landscape*, and it has no ending. Hosoe returned to the downtown streets he had wandered as a young photographer, where he fell in love with one of the prostitutes but later discovered she was a man. The discovery neither caused him to terminate the relationship nor diminished his desire. It was an introduction to an adult world that took place against the backdrop of Asakusa and the Azumabashi Bridge, where the prostitutes solicited beneath the signs of the Asahi Brewery. The brewery still stands, the lanterns and the bars remain, but now the bridge is empty and the back streets have become remnants. Hosoe used a young actor to portray Simon, distraught, dressed like a tattered Pierrot, clinging for human contact as well as business in a stark and threatening world. The series is halfway to completion. The remaining work will be landscapes at the edge of the city, devoid of figures. The course of the series is set. The climax will be a void. The series may take Hosoe the rest of his life.

The terror of that August is experiencing the weathering effect of time and is eroding. We are unable to stop its steady advance. Moreover, we must resist the natural erosion that memory is subject to. We must build a dam against the flow of time.

SHOMEI TOMATSU

SHOMEI TOMATSU

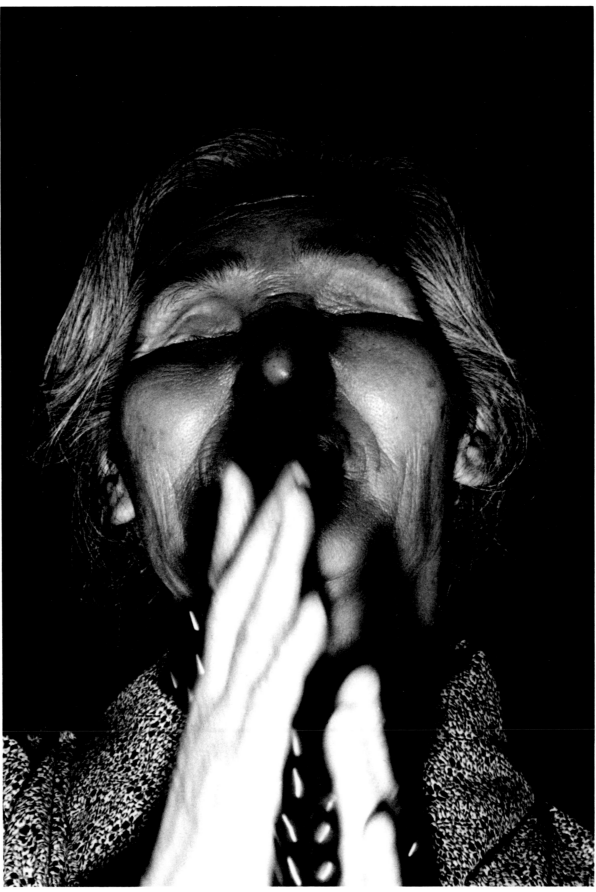

OSOREZAN, THE MEETING OF THE SPIRITS OF THE DEAD, 1959

33

TIME STOPPED AT 11:02, 1945, NAGASAKI, 1961

NIPPON

THERE is a photograph by Shomei Tomatsu of a watch that stopped at 11:02 A.M. on August 9, 1945, at Nagasaki. The circular watch face at the center of a square photograph has iconographic form, a fragment framed like a mandala. It was taken more than a decade and a half after the event. Photography, with its inherent facility to halt the transience of the moment, has been applied to a static form to make a symbol of permanence. The watch becomes a monument constructed through detail and precision. The minute hand points just past the 12, as fixed as the memory of the event. The erosion of that memory is as impossible as the motion of the minute hand past 11:02.

The events of 1945 are usually described like all disasters, in statistical terms. At Nagasaki there were 73,884 dead, 74,909 injured, and 120,820 victims of radiation. The temperature at the epicenter was 6,000°F. As the bomb exploded 490 meters above the city, the day, the hour, and even the minute

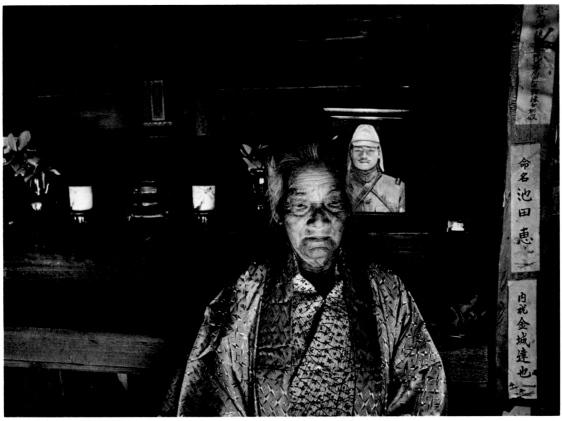

IRIOMOTE ISLAND, OKINAWA, 1972

are fixed. Present time moves to future time like the countdown to Tsukuba on the digital clock in Shinjuku. Nagasaki time is frozen. August 1945 is the full stop toward or away from which Japanese history must be measured. It marks the birth of modern Japan.

Shomei Tomatsu's life, like that of all of his generation, revolves around the memory of that year. Brought up to believe in the demonic or monstrous characteristics of Westerners, he opened the door of his home in Nagoya to see the streets packed with American troops and jeeps. In 1945 he was fifteen years old. He passed from adolescence to adulthood under a state of occupation, with an American base in his home town. The watch face is his pivot; the work he has produced over the last thirty-five years revolves about that minute. His work began with the Occupation. His first book was *Nagasaki: 11:02* (1966). Forty years after Nagasaki he has found a refuge in those parts of Okinawa where there is no sense of the Occupation, where he can experience Japan before the watch stopped, at the furthest point on a circle circumscribed from the year 1945.

Behind the fences of the American bases was a detached world of plenty.

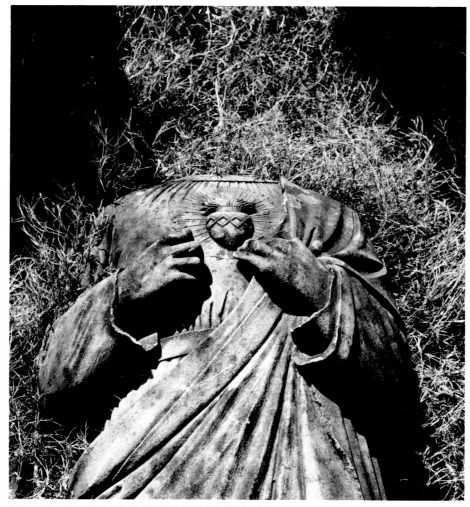

STATUE OF SAINT THAT WAS BEHEADED BY THE ATOMIC EXPLOSION, 1945, NAGASAKI, 1961

Well-fed troops dispensing chocolate and chewing gum to the children did much to destroy their monstrous myth. The mystery of the Americans, especially the black servicemen, was dispelled by the initial limited contact between the occupying army and a hungry population. Tomatsu remembers resorting to stealing food from the fields, which the farmers protected with guards. The game of crawling past the guards to devour the food on the spot was more than teenage daring: it was a survival strategy. The Americans and the Chinese and Filipinos who worked on the bases were the only ones who did not share the hunger. The bases became an obsession to Tomatsu, as they represented the source of the Americanization that swept Japan from Hokkaido to Okinawa. When the Americans left Nagoya, Tomatsu continued to photograph at every base in the country. There he encountered the force of Americanization most directly. Later this confrontation became a means of assessing his own life and testing his reaction as a Japanese to the continued presence of an alien army and all its attendant baggage.

Tomatsu never knew his father, since his parents divorced when he was very young. His elder brothers had a darkroom where he could observe the magic of the photographic process. While still at school he maneuvered

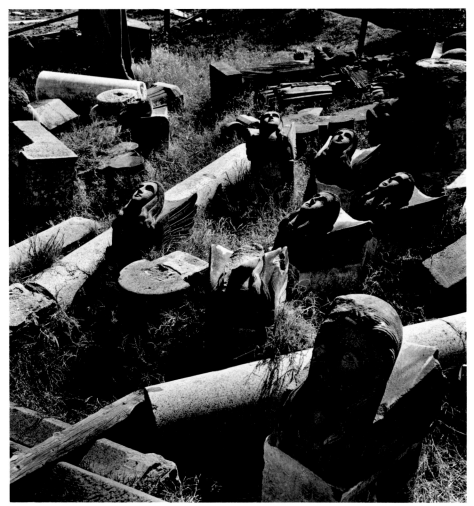

URAGAMI TENSHUDO CHURCH, NAGASAKI, 1961

a meeting with a girl under the pretext of taking her photograph, then was astonished as he printed his first portraits. By 1950 he was using a camera regularly. He held his first exhibitions at Aichi University in Nagoya, where he was an economics student. His professor warned him that his photographic work was too Dadaist. Beneath the surfaces of Tomatsu's documents of modern Japan lurks a quality of surreal juxtaposition and transformation that transcends a purely photojournalistic intention.

The black servicemen are the dominant presence in his Occupation pictures. In the blacks there was a recognition, at times perhaps mutual, that they carried the weight of a culturally displaced history. Under their most demonic exterior, created out of wartime Japanese propaganda, they were identified by Tomatsu as sympathetic creatures. He was attracted by them, but his photographs reveal the threat of their presence, at times in a sexually explicit fashion. Tomatsu witnessed the aftermath of rape and murder, yet speaks of those first years as an irreversible reality.

Shiiku (*The Catch*), the novel by Kenzaburo Oe that Nagisa Oshima adapted to film in 1961, describes the capture of a black airman by Japanese villagers. The airman was treated by the villagers as an exotic animal, devoid of human

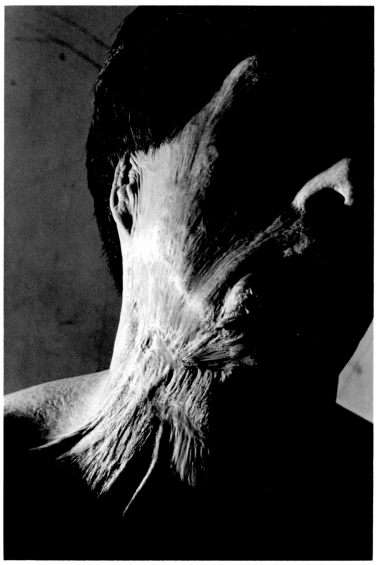

NAGASAKI, 1962

status. The mystery of the black American echoed Tomatsu's photographs and his own initial fear of the occupying forces. Tomatsu worked closely with Oshima on the film, not as a cameraman but in establishing the course and setting of the drama. Tomatsu photographed the actors in their roles as formal portraits and included these in his major body of work at the time, *Nippon*, confirming the veracity of the village characters whose fear and bewilderment he had once shared.

Among the figures that inhabit Tomatsu's work from the fifties are those on the periphery of society: a circus player in rags asleep, a child asleep in the dirt, as if weariness was the climate of the time, reflected in the poverty of the streets and the housing. There is a sense of continuity, of a struggle to return to some kind of normality, in Tomatsu's depiction of a disparate social panorama including farmers, students, schoolchildren, quarry workers, harbor fronts, trams, and street bustle. In the populace and fabric of Japan he has located a sacred core. There are photographs of stone Buddhas in the undergrowth by the wayside of some ancient track, pilgrims ascending a mountain, and the faces of mediums from the country in trancelike communication with another world. Among these descriptive photographs is the

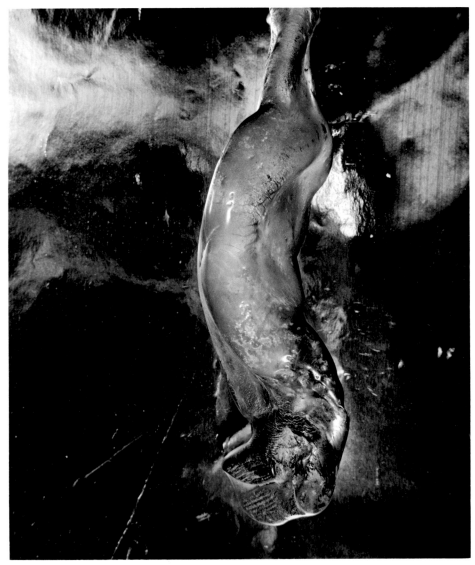

MELTED BEER BOTTLE AFTER THE ATOMIC EXPLOSION, 1945. NAGASAKI, 1961

pure abstraction of a shallow river, endowed by virtue of its association with the sacred imagery with the connotations of a holy river, or a Japanese symbolic course. The light on the surface of the water, and the pattern of the pebbles beneath, take on a visual equation with the corroded and marked surfaces of decay. The work shows a refined aesthetic formed from a brutal reality of mud, rust, weeds through cracked concrete, bullet holes, and scorch marks.

There is a sense of survival and recovery in the persistence of the traditional core despite the evident scars. The farming and seasonal cycle is photographed not in explicit representational form but through the understatement of a single figure knee deep in the mud of the rice fields or a hoe raised against the mist over a mountain. These are the archaic endeavors of cultivation and eventual civilization. They are matched by Tomatsu with the fury of typhoon and flood. The sun or moon is reflected in the surface of a flooded field with the spareness and precision of haiku. In the same breath the aftermath of a typhoon is recorded with poetic understatement in the evidence of Tomatsu's own home: a boot, a bottle, domestic debris float in the slime of the storm, framed as fragments of his life. Through Tomatsu's camera you are privileged

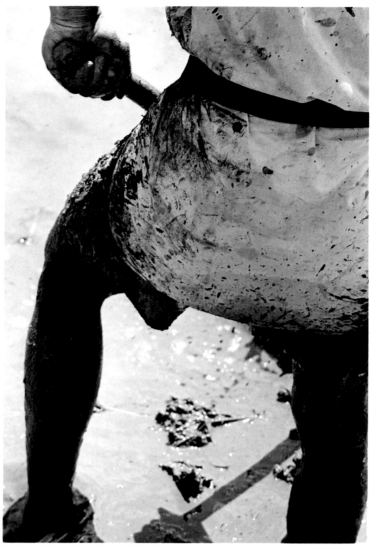

AFTERMATH OF A TYPHOON, NAGOYA, 1959

to share more than the objective role of witness: you participate directly as victim.

In 1957 Tomatsu made a series of photographs of a local politician from the country outside Nagoya. The choice is curious, and the form is more like the conventional picture story, yet the series has a poignancy suggesting the old roots and the permanence of daily rounds in the country. On his own admission Tomatsu chose the politician as a figure the same age as the father he never knew. The politician series forms part of *Nippon*, connecting the national roots of an exterior Japan to the personal roots of the photographer in a search for a figure stolen from childhood. No wonder Tomatsu felt a strange affinity for the black servicemen with their chocolate and chewing gum, bearing gifts for fatherless children.

By 1959 Tomatsu's style of abstraction, of moving the camera close to the surfaces he described, was established. He photographed a farmhouse interior, transforming the details into symbolic patterns. An iron bowl, a kettle, the blade of a knife look like excavated artifacts, a personal archaeology. Tomatsu was examining the farmhouse of childhood memory. The tatami mats on the floor are photographed from low down, seen from the angle of a crawling child. Fish bones, trapped flies, a dead mouse are part of the deserted and

AFTERMATH OF A TYPHOON, NAGOYA, 1959

morbid tone. A man's hat hangs by a clock that points to 5:45, the time the father of Tomatsu's imagination might have returned from work.

When Tomatsu went to Nagasaki in 1961 the harbor city where Portuguese sailors and Jesuits once wandered was marked by the presence of sailors from the American fleet. A carrier was anchored in the bay. Tomatsu's portrait of the city has an exterior of lanes and alleys, old rooftops, and stone lanterns. Down at the harbor fish are being unpacked and crated, children play, marching bands parade in American uniforms. The Christian heritage is still evident from past links with the West. There are crosses on the hillside.

Behind this exterior of the city was an interior Tomatsu composed out of scar tissue. Just as he had recorded the grain of the farmhouse timbers, he moved the camera close to the skin of the bomb victims, isolating limbs, but countering the grotesque surfaces with signs of survival or domesticity—a comb in a hand at the end of a mutilated arm. He also photographed the fallen statuary of the city, the rubble of history in the grass. A decapitated standing statue unavoidably becomes an image of a nation without a true face. The quality of the stone provides a detailed surface, balanced by the effects of light on water in the harbor, or corresponds to the pitted flesh of a victim. Tomatsu has arranged a catalogue of scorched objects: a beer bottle

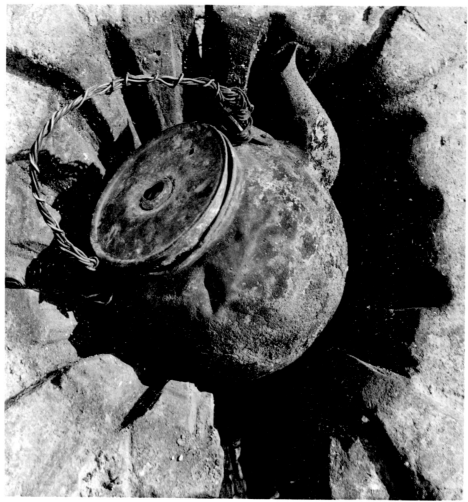

FARMHOUSE, 1959

contorted in the heat of the explosion is transformed into an image of the contortions of the flesh. A finger and a rosary complete the array of fragments.

Domon's work drawn from his book *Hiroshima* (1958) was included with Tomatsu's work from Nagasaki to form a polemical catalogue of evidence, *The Hiroshima–Nagasaki Document* (1961). In 1962 the Nagasaki work was exhibited at the Fuji Photo Salon in Tokyo, and it was finally published as a book, *Nagasaki: 11:02*, in 1966, at a time when Japanese society, catapulted by economic transformation and personal sacrifice, had the statistical reward of an exploding gross national product. It was precisely at that point of social and economic transformation to economic superpower, with new international status following the Tokyo Olympics in 1964, that such a document was a shocking reminder of 1945. Tomatsu was committed to halting the erosion of the memory. In contrast to Domon's style, Tomatsu's style was able to portray Nagasaki as a deceptively beautiful though tragic port. The last photograph in his book is of American fighters on the deck of the carrier.

When Tomatsu photographed industrial plants, refineries, cargoes of export vehicles, and shipyards in the sixties he included a sense of desolation. The wastelands of a new prosperous Japan, the bleakness of the new housing

FARMHOUSE, 1959

blocks, emphasized the illusion evident in the economic change. While trade statistics improved, a quality of life was vanishing. The roots of the nation in the fields and even in the fish markets of Nagasaki, as asserted by Tomatsu, were displaced by the industrial zone. The desolation was both reminiscent of the postwar years and a premonition of the environmental disasters that were finally registered publicly in the early seventies. In 1970 Tomatsu photographed the Ashio Copper Mine, where the open quarry had ravaged a hillside beside a graveyard: the foliage was dying, the air was a poisonous haze, and a river of waste formed a mountain of slurry. In 1971 W. Eugene Smith began to record his Minamata document, moving his camera close to the waste pipes of the Chisso Corporation to produce images of patterned surfaces of polluted water. The mercury poisoning that destroyed the livelihood of the fishing community of Minamata with such terrible human consequences informed the polemic of the Minamata document with a significance that was both national and global. Smith's remarkable achievement, with its specific local evidence and its occasional iconographic vision of individual suffering, amplified the destruction accompanying unqualified economic motivation that characterized Japan at the end of the sixties, a time of worldwide

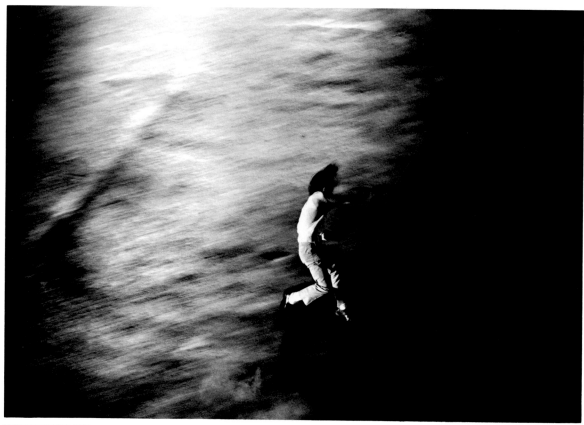

PROTEST, TOKYO, 1969

unrest. The rejection of the GNP as the sole criterion of recovery was re-
flected in the violence of 1968, which linked Tokyo to the rebellion smoldering
in every European capital.

As the forces of the Zengakuren, the radical-left union, were mobilized in
dramatic form in the streets of Tokyo in 1968 or in the siege of the university
by the students, a new creative freedom was expressed. Nagisa Oshima's
film *Diary of a Shinjuku Thief* (1968) drew on underground performance art
and Shinjuku street culture with innovative film technique. Hijikata's Ankoku
Butoh-Ha and Terayama's Tenjosajiki championed a new Japanese avant-
garde form of theater. At one point Terayama's group was composed almost
entirely of runaways, self-imposed social outcasts. His film *Sho O Suteyo Machi
E De Yo* (*Throw Away Your Books, Lets Go into the Streets*) (1971) reflected
the mood of alienation. Tomatsu collaborated with both Hijikata and Ter-
ayama in a climate of artistic and social revolution. A whole generation of
Japanese were challenging the motivations and lifestyles of their country. The
Japanese designers and artists who came to prominence in the seventies,
including the graphic designer and painter Tadanori Yokoo, and Rei Kawak-
ubo of Comme des Garçons, the most purely Japanese fashion-design

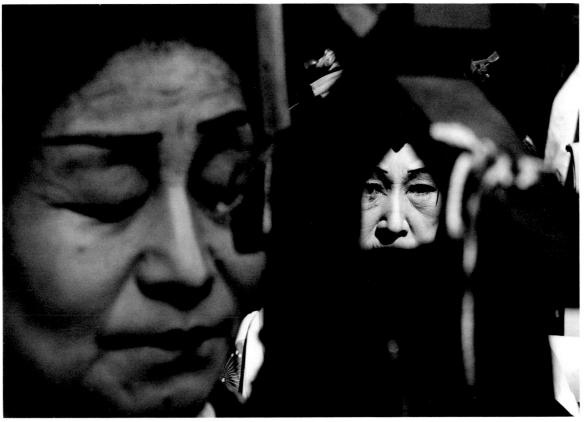

SANDWICH MEN, TOKYO, 1962

house, were products of this upheaval. Once they had broken from extreme Japanese social conformity they were free to challenge the conventions of their own medium internationally by maintaining styles marked with a particular Japanese identity.

Much of the student unrest in Japan, as in America and Europe, was unified through opposition to the Vietnam War. In Japan this opposition could be specifically aimed at the continuing American bases serving the war in Southeast Asia. Political rebellion against American policy coincided with internal social rebellion, especially against the values of American culture nurtured through the Occupation. Economic confidence coincided with artistic confidence and the need for a native avant-garde art. The creative whirlwind of the time made possible links between Mishima, a figurehead of a nationalist ethic and a patron of the avant-garde, and Oshima, a filmmaker with a Marxist background. The two in fact met in public debate. The categories of left and right do not form the fundamental dialectic of Japanese political values as they do in the West.

Tomatsu photographed the Shinjuku riots of 1968 in graphic style. The city formed a backdrop to the pitched battles between students and riot police.

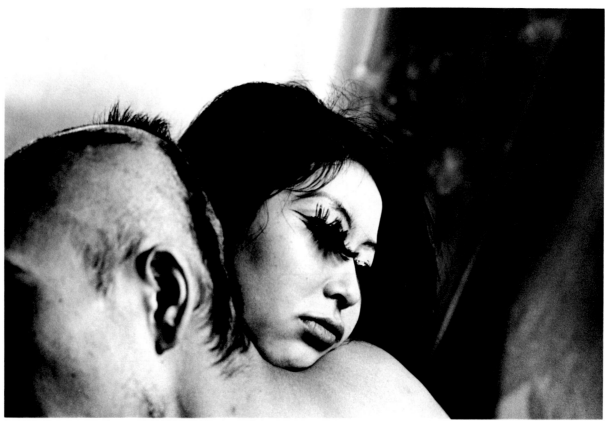

EROS, 1969

Tomatsu simultaneously photographed an interior Shinjuku, ripe with the eroticism of a new social freedom. The conjunction of sex and violence is commonly exaggerated in Japan with the public display of a pornographic violence either in cinema or within the graphic conventions of comic strips that are more preoccupied with ravagement than humor. With the participation of a *Butoh* performer and his wife, Tomatsu photographed explicit sex, while outside the window the streets were erupting. There is a terrible grimace on the face of several of Tomatsu's subjects that links a climactic scream with the silent howl from the open mouth of a girl with a Molotov cocktail. Similarly, Mishima's eroticism in *Barakei* can never be totally disso-ciated from the erotic aesthetic of his Tate no Kai (Shield Society), his "private army" of young men who formed "Beauty's kamikaze squad."

By 1970 the explosion of the preceding two years had passed. In addition to the Osaka Expo the year was marked by the Revision of the Security Treaty with the United States, which sustained the American presence in Japan. Great demonstrations were anticipated, but none occurred. On the day of the Revision, Mishima was driving with his friend Donald Keene past the Diet building. Riot police surrounded the area, but there was little evidence

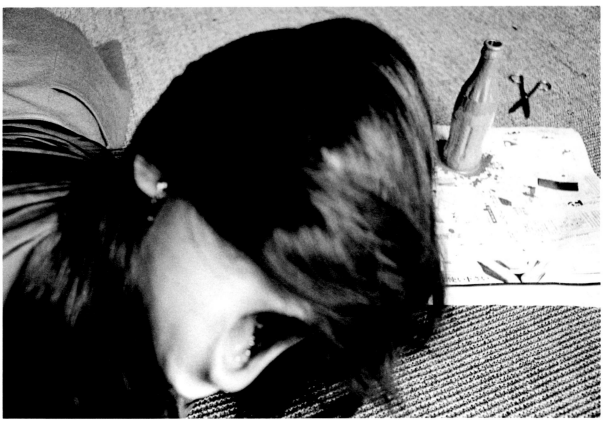

1969

of opposition. Mishima commented to Keene that he was disappointed. Although he was ideologically divorced from the left, he respected the conviction of their expression. In November 1970 Mishima complete his final cycle of four novels, *The Sea of Fertility*. He worked furiously with Hosoe and Yokoo to finish production of a monumental edition of *Barakei* (to be called *Ordeal by Roses*): then, in accord with an intention he had already stated, that had been interpreted as almost a poetical exaggeration, he committed suicide at the barracks of the Self-Defense Force at Ichigaya in Tokyo after delivering a speech to the troops and the assembled media accusing Japan of being "drunk with prosperity." His final act stunned the world but was greeted with some disdain in Japan. The domestic reaction, with counteraccusations that Mishima was a sensationalist and an exhibitionist, perhaps reflected the accuracy of his accusation. He provided the climax of an era in a style that had not been so shockingly demonstrated since 1945. He reminded the Japanese of the need to preserve their identity in the face of forces that would challenge Japanese tradition, at the heart of which was an emperor descended from the sun goddess, who cast her rays with divine beneficence over an island race.

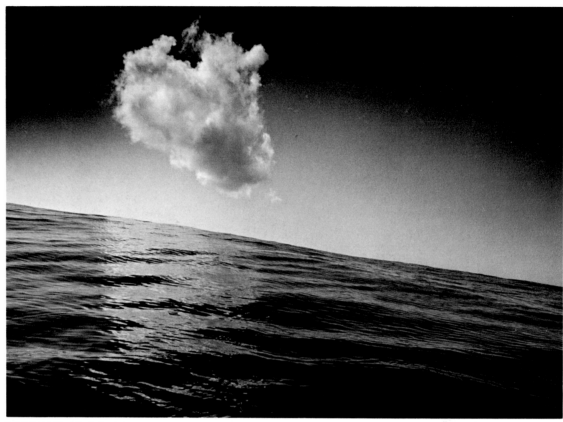

HATERUMA ISLAND, OKINAWA, 1971

MEMORANDUM

1970: Carlsbad Caverns, then I moved to
White Sands National Monument.
Dr. Albert Einstein,
government officials and the Pentagon
all watched
the mushroom-shaped cloud
right here in the Chihuahau desert
25 years ago.

1973: Jemez Springs, New Mexico,
I met a Christian priest.
At Tinian Air Base in Micronesia
he held a service for "B-29" pilots
who headed for Hiroshima,
August 6, 1945.

1945: Izumi Air Base in Japonesia,
100 miles south of Nagasaki.
Three days after the Hiroshima bombing
I caught a "B-29" on my radar screen.
Due North. 30,000 feet high. 300m.p.h.

Three minutes later
my soldiers shouted,
"Look, a volcanic eruption!"
In the direction of Nagasaki
I saw the mushroom-shaped cloud
with my own eyes.

1946: Hiroshima. There,
one year after the bombing
I searched for
one of my missing friends.
As a substitute for him
I found a shadow man.
The atomic ray instantly
disintegrated his whole body,
all—but shadow alive
on a concrete wall.

1969: Bandelier National Monument.
Beautiful ruin
of ancient people, the Anasazi.
Dead of night, the earth

quakes three times.
Not by Jemez volcano
but by underground nuclear explosion
in Los Alamos.
More ruins, more churches!

1975: The Air Base ruin in Japonesia,
south of Nagasaki.
No more "Kamikaze pilots,"
now 3,000 cranes soaring high
in the setting sun.

1979: Northern edge of Chihuahua desert,
Bosque del Apache National Wildlife Refuge.
Sandhill crane, "Grus canadensis": 1,700.
Whooping crane, "Grus americana": none.
As a substitute
for the extincting species
Mr. Kerr-McGee wants to dump
ever-existing nuclear waste
into "The Land of Enchantment".

NANAO SAKAKI, 1979

48

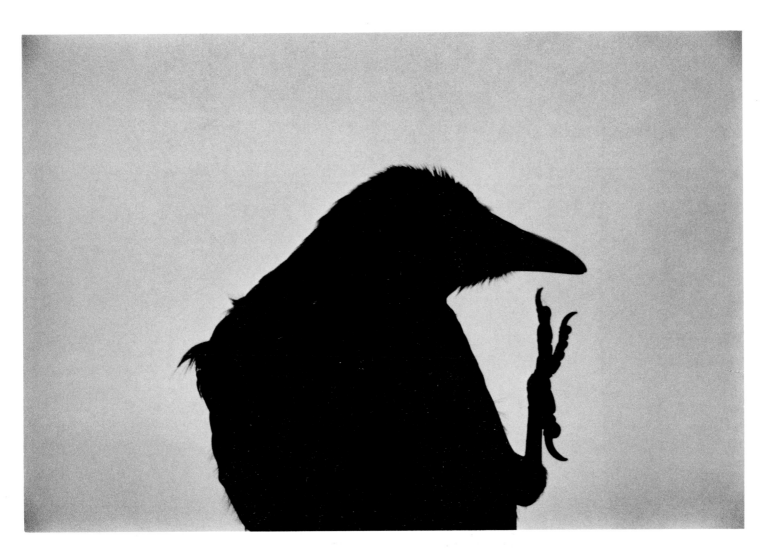

In my first thirty years of life
I roamed hundreds and thousands of miles.
Walked by rivers through deep green grass.
Entered cities of boiling red dust.
Tried drugs, but couldn't make Immortal;
Read books and wrote poems on history.
Today I'm back at Cold Mountain:
I'll sleep by the creek and purify my ears.

FROM HAN SHAN, COLD MOUNTAIN,
TRANSLATED BY GARY SNYDER

**MASAHISA
FUKASE**

THE JOURNEYS NORTH AND SOUTH

SOUTH of Kyushu is the small volcanic chain of the Amami Islands, which spread down toward Okinawa and the Ryukus. Gary Snyder has described this chain of islands in *Earth House Hold* (1969) as stepping stones for paleolithic travelers en route to Japan. The eruptions have prevented permanent settlement, and the difficult terrain has preserved the habitat as a hard but undreamed-of paradise in modern Japan. In the sixties, on one of the active volcanoes, Snyder worked with Nanao Sakaki, a poet and traveler. They built a farming community in association with the Emerald Breeze, a tribal group of urban refugees who established their values in an archaic, primary tradition, through whom Snyder realized and developed his own sense of tribe. The community farmed and spearfished in the tradition of their paleolithic ancestors beneath the booming volcano. Nanao's inspiration came

from years of traveling throughout Japan in the long tradition of the wandering poet, like Basho on his great journey described in *The Narrow Road to the Deep North.*

Cold Mountain is a poem by Han Shan (Kanzan in Japanese), a Chinese hermit from the T'ang dynasty who scribbled his poems on the rock face of a mountain in a colloquial T'ang dialect. Cold Mountain is a place; it has an exterior location. It is also found on an interior map. It is an invisible point, a void. The journey to Cold Mountain is the course of the poem. Some men never get there. Snyder translated *Cold Mountain* with the confidence of a poet describing his own journey. He has transcended his own time with the voice of his predecessor, who was writing twelve hundred years before. Nanao's journey to the southern volcanic island was an attempt to establish a source of personal history in the footsteps of the prehistoric settlers. Cold Mountain exists in Japan as it does in China. Han Shan, Snyder said, can sometimes be found in the "hobo jungles and logging camps of America." Japan can

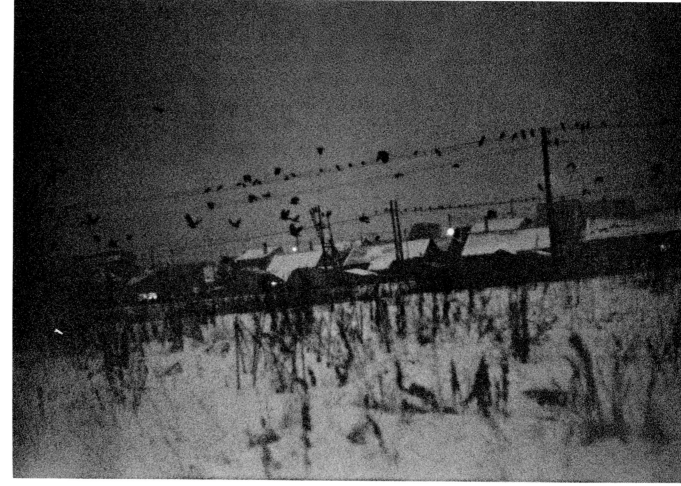

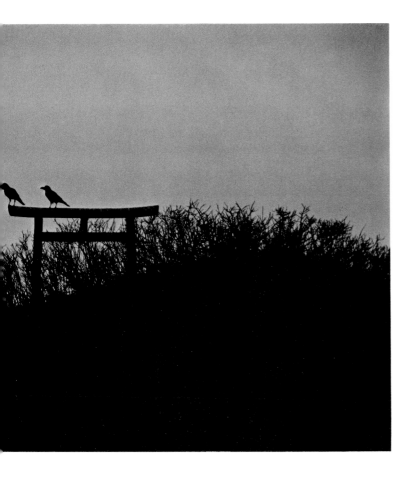

present a sense of time that supersedes a sense of place. The journey south beyond Kyushu is an exploration of source as personal and profound as that of Hijikata and Hosoe following the myth of Kamaitachi. The sense of the journey is shared by all the characters who move through the text, defining their own lines on the map.

Tomatsu's redemption from the pain of Nagasaki, or from the bleakness of the industrial zone spreading unremittingly down the east coast of Honshu as far as Hiroshima, is on a small island close to Okinawa. Away from the American bases he has found the vestiges of a culture he claims as his own. Fishing and farming, physical exuberance, and the proximity of the ocean offer relief and sustenance. For more than ten years Tomatsu has returned frequently to Okinawa to establish a sense of home after the itinerant nature of his work. His observation of the islanders' festivals and masks heightens the mystery of the island refuge and avoids the perpetuation of exotic clichés. The faces of the islanders, the men on

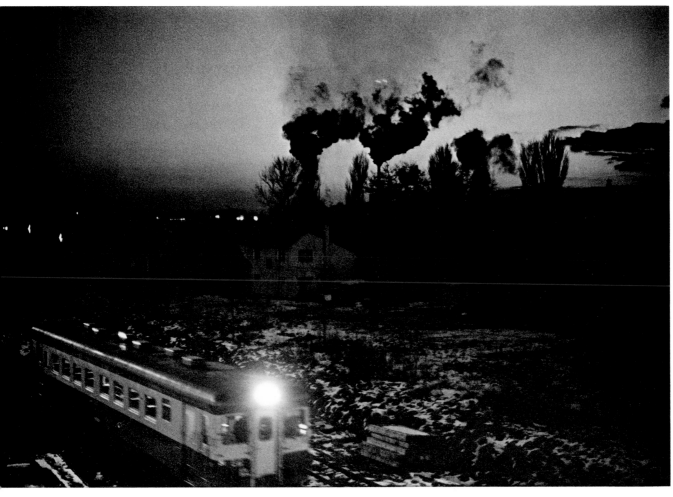

the water or the women waiting at the quayside, contribute to the image of a separate world marred only by the intrusion of a calendar pinned inside a hut or of a Coca-Cola bottle at the feet of an island musician. Tomatsu photographed the arms of the women outstretched toward a boat on the horizon, a sign of farewell. There is a photograph of a small cloud, blown against a tilted horizon, drifting over the ocean, defining Tomatsu himself, like Basho, who roamed through a transient world. An island tomb in one of Tomatsu's photographs sprouts weeds through its cracks like an overgrown gun placement from the war. The curve of the roof of the stone chamber is swollen like the belly of a mother. The point of entry to the land of the dead corresponds to the passage of birth.

Tomatsu's influence on a younger generation of photographers in Japan was great. He provided a form derived from a Japanese source. Graphic, with an emphasis on surface at close quarters, and audacious, his work was constantly asserting a Japanese tradition in new form. The metaphor of the journey as the im-

plied narrative to major areas of his work was reiterated in the work of Masahisa Fukase and Daido Moriyama, whose long sequences in fierce graphic style have provided some of the most innovative work over the last fifteen years.

In 1976, following his divorce from his wife, Yokho, Fukase began a train journey to the northern island of Hokkaido, his birthplace. It was an ominous journey, filled with symbols that pointed back to his personal history. The journey was the start of his unfinished epic series *Crow* and the return to his starting point. Fukase's family was descended from the nineteenth-century colonists who had been among the original settlers on the northern island. His father had a portrait studio in the town of Bifuka, and his mother helped in the darkroom. In the early fifties Fukase had come south to Tokyo to the photography department of Nihon University. Some of his student work from Tokyo in the early fifties has recently been reprinted and constitutes an extraordinary document of the vitality of the city so shortly after its devastation. The maze of alleys with small bars and restaurants to the west of

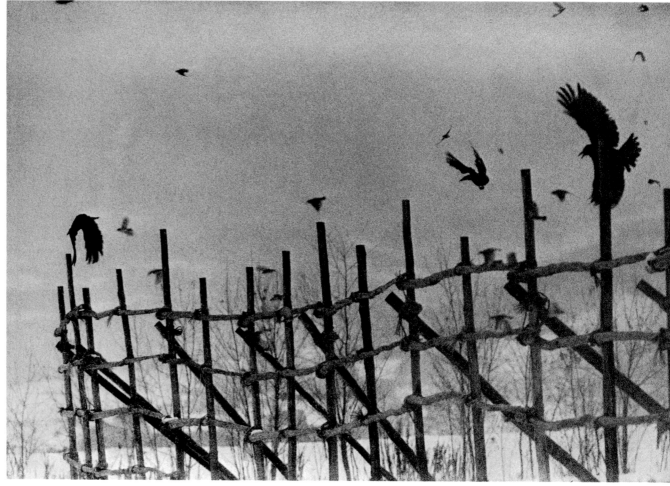

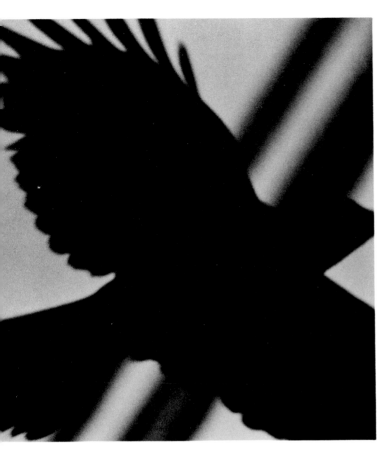

Shinjuku Station that he photographed is unchanged today. The American military presence is very evident in many of the photographs. Gangsters, servicemen, bargirls, and entertainers attracted his attention, as they did that of many other young photographers of the time intent on broad social documents. Fukase's greatest influence in the fifties was Yasuhiro Ishimoto, whose Western training at the Art Institute of Chicago had such great effect in Japan. Fukase's sensibility often included a chilling, even provocative element far removed from the refined aesthetic of Ishimoto. One of Fukase's first exhibitions, *Kill the Pigs* (1961), was based on photographs taken in a slaughterhouse. In his book *Yokho* (1978) he placed these photographs next to portraits of his bride at their wedding in 1964. She was a Noh performer, and she posed as a dancer in black beside the meat hooks, then appeared at the climax of the book in the full flow of her performance. The theater and the stage were firmly established as the conventions of the unwritten narrative that follows the long sequence of this work.

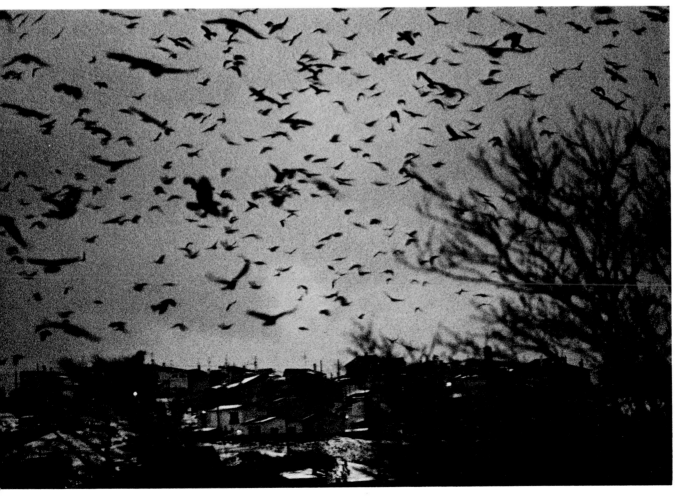

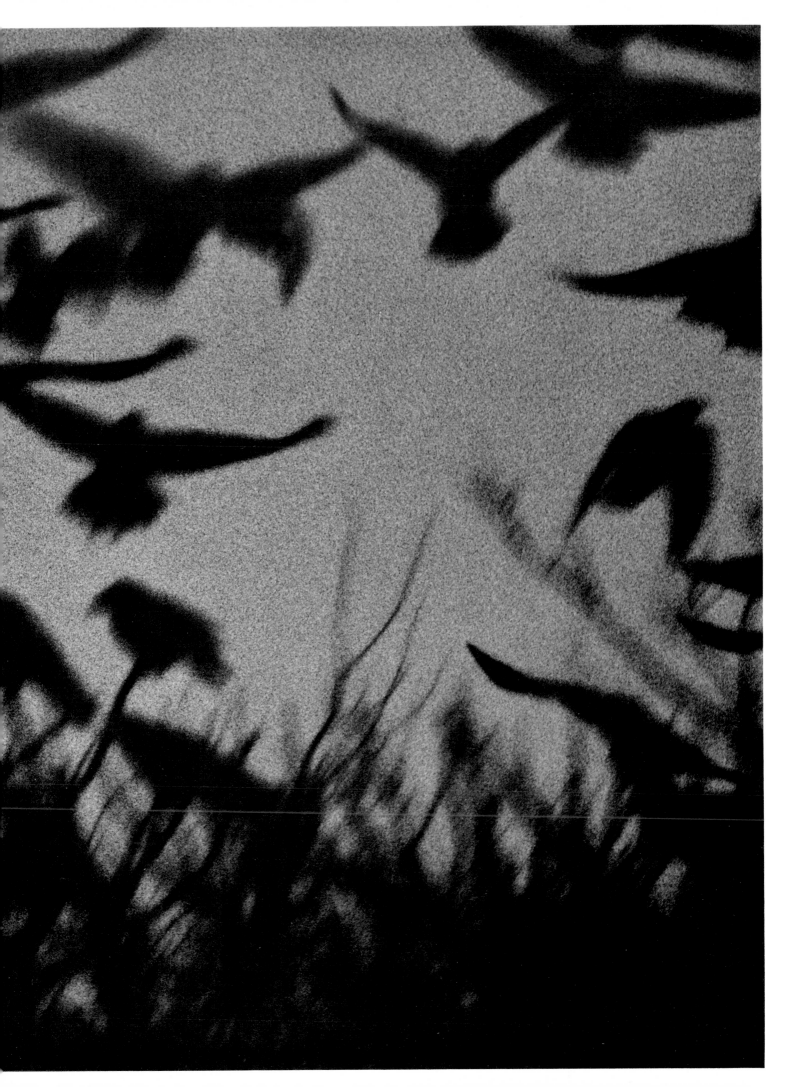

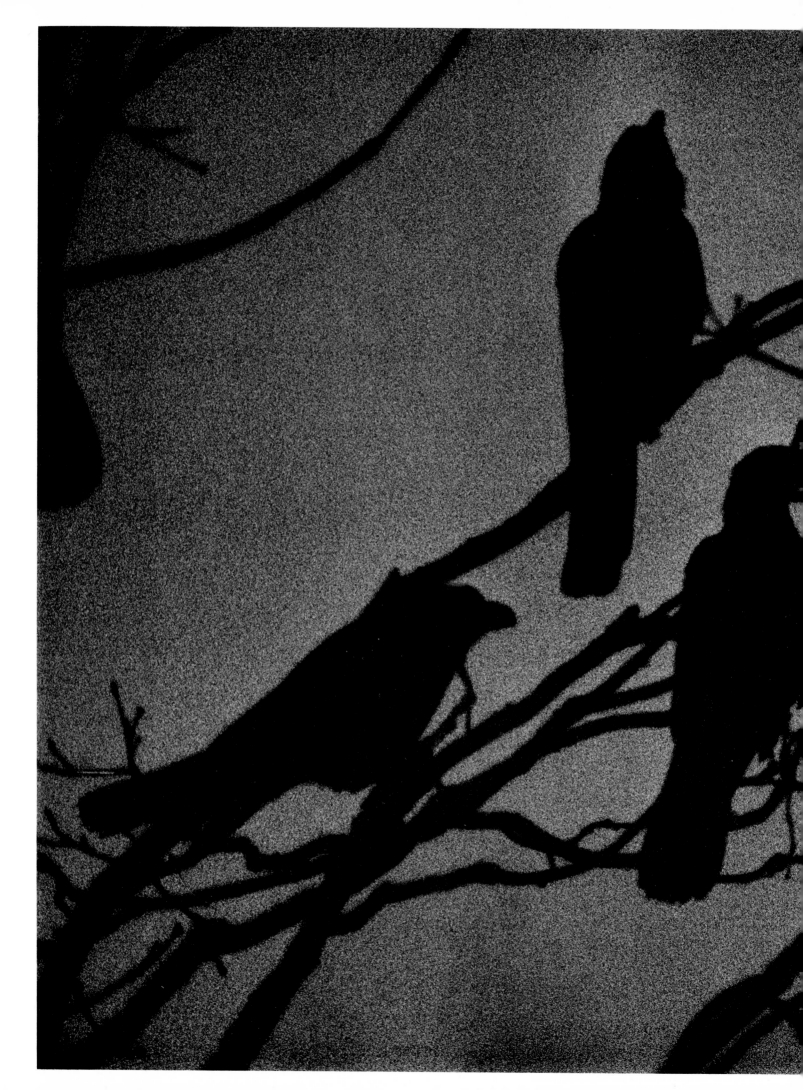

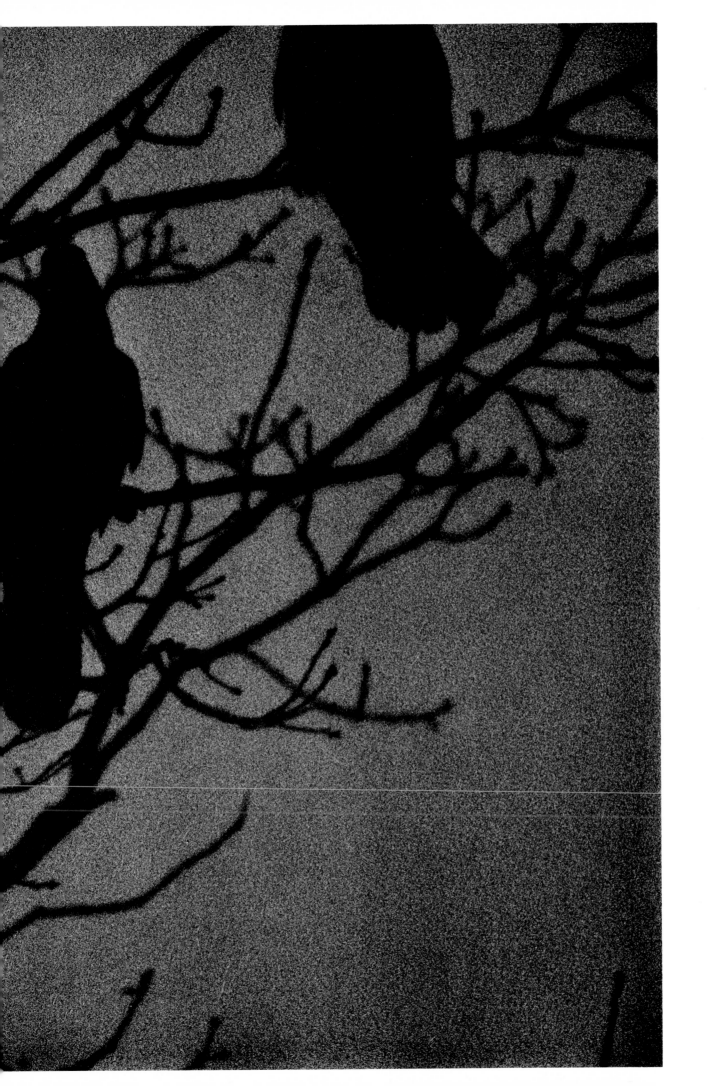

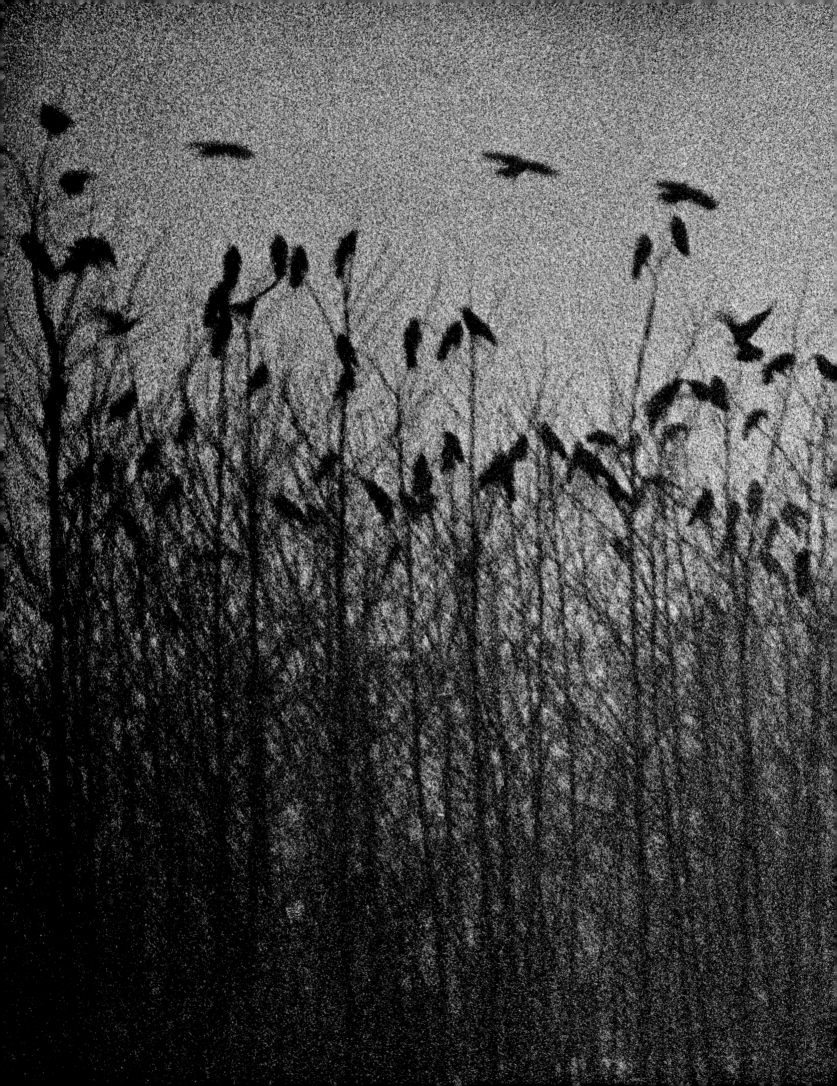

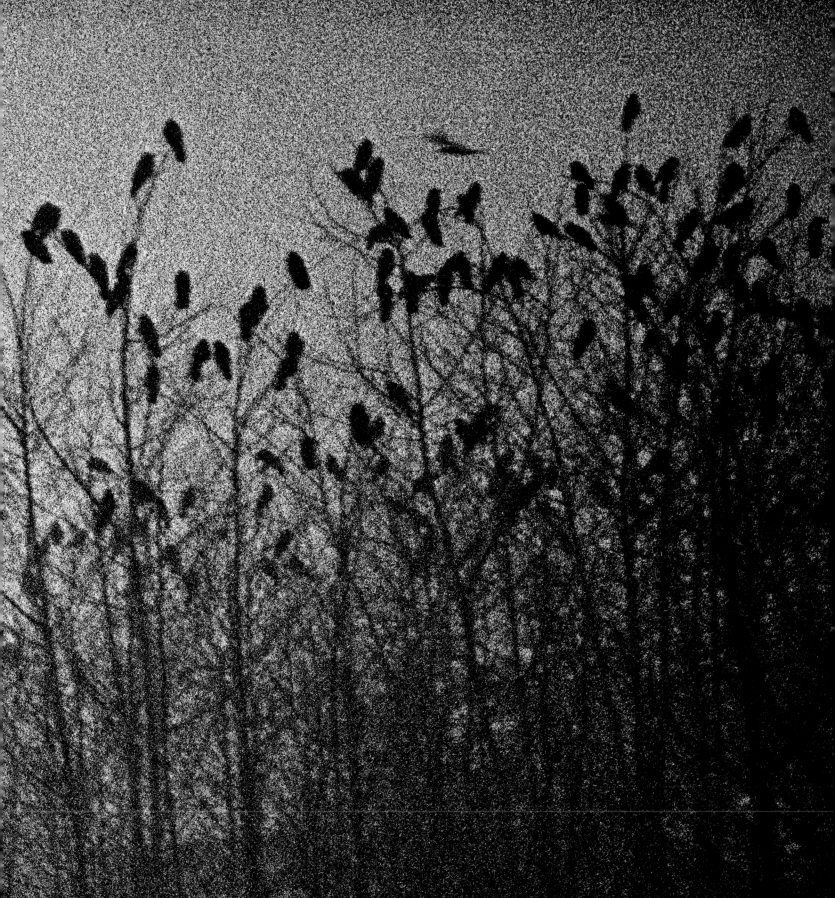

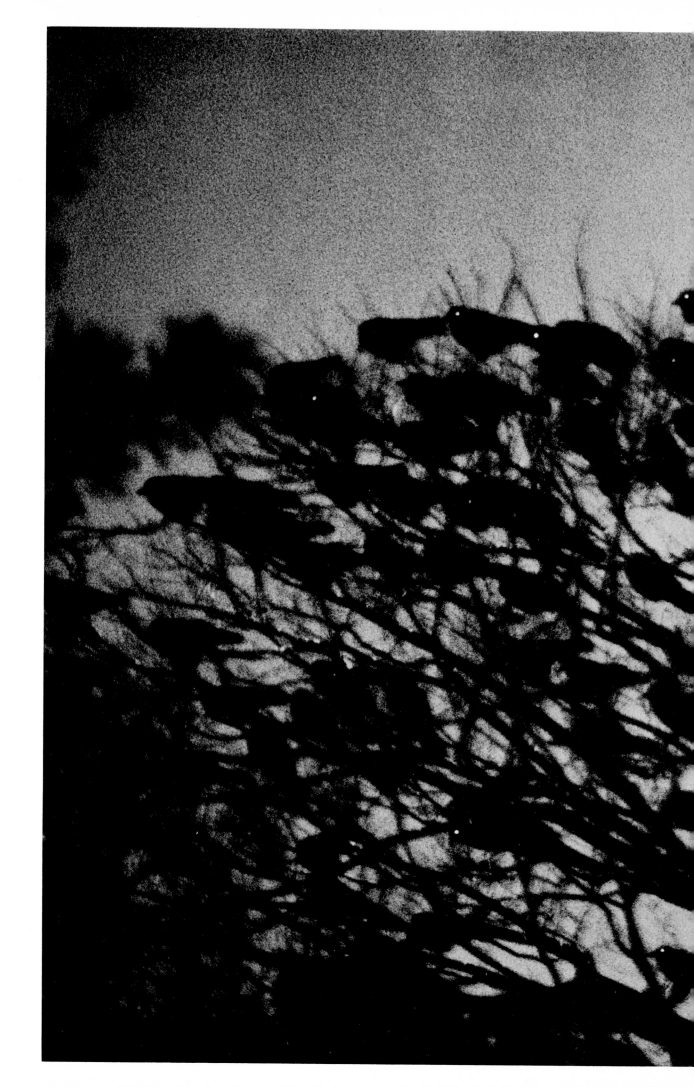

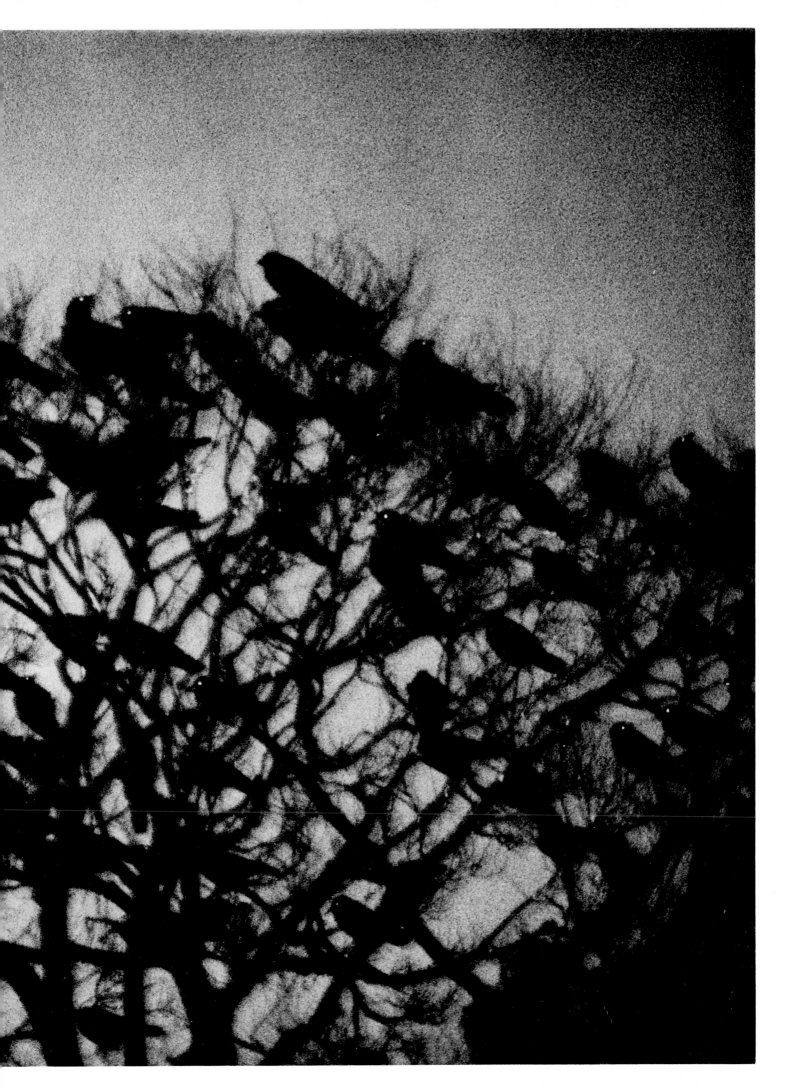

Fukase moved between a new-town housing project in Saitama Prefecture, where he lived with his wife in the sixties, and Shinjuku, where he had established a studio in 1968, at a time when the streets were alive with the sense of a wide social revolution and an illusory climate of sexual liberation. His first book, *Homo Ludence* (1971), is the evidence of that freewheeling time, when social, sexual, and photographic conventions could be stretched with license for endless possibilities. Shinjuku orgies are part of the play described by *Homo Ludence,* and Fukase's blurred, almost abstracted forms of entangled bodies satisfied the voyeuristic desires so prevalent in Tokyo. They also suggest the photographer as participant, not just observer.

His marriage to Yokho is Fukase's essential subject. The journey north in 1976 is darkened by their separation. Out of the train window on his way to Hokkaido Fukase began to photograph the crows. They are sym-

bols of ill omen in Japan as in the West. Their inauspicious presence became overwhelming. From the moving train can be seen the lights of the snowbound houses, some blurred figures by the track; the motion reduces the images to their most graphic form. The silver eyes of the crows, sometimes caught in the glare of a strobe light, reflect specks of light against their clustered black outlines on a tree or a telephone wire. The crows become the sinister witnesses to Fukase's journey. Beaks and claws, the sharp edges of the scavenger, create a dangerous presence. Between the large studies of the birds in their black pictorial form, like the calligraphic brushstrokes of a *sumie* ink drawing, are the grained abstractions of Fukase's prints. An outline of dark wings against a coarse-grained pattern is transformed into the shadow of a plane. A bomber overhead is a traumatic shape in the Japanese imagination. The blurred figures by the railway track take on a different connotation as the melancholic

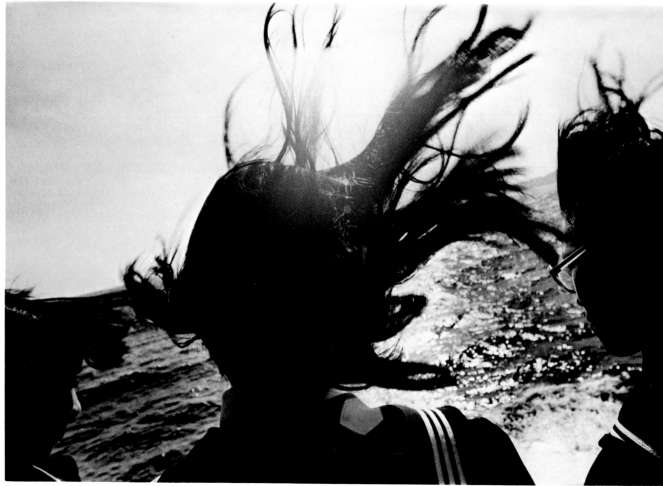

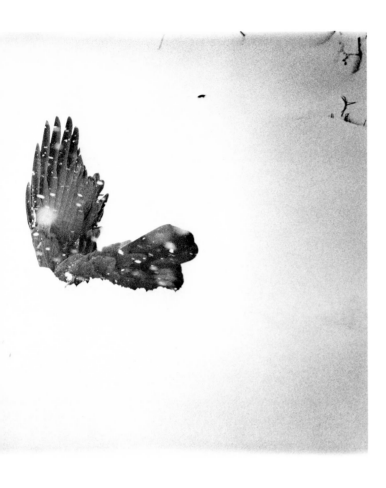

pictorial grace is disturbed by a darker, apocalyptic symbol.

The personal route of Fukase's northern journey is extended with his further travels. The crows continue to inhabit his photographs: on the wastelands of Tokyo Bay among the garbage of a great consumer society, or on an empty beach beside a fire of washed-up debris, there are the tracks of crows' feet in the snow. Crows perch on the *torii* arch of a Shinto shrine or hover above a giant statue of Kannon, the Buddhist goddess of mercy. The black hair of a schoolgirl flaps in the wind like the wings of a bird, and personal history and desire are merged with a national course. The shape of outstretched wings overshadows Fukase and his time. A shadow language emerges that links the silhouettes etched in radiation on the stones of Hiroshima to the shadow of a photographer haunting the frame of his image.

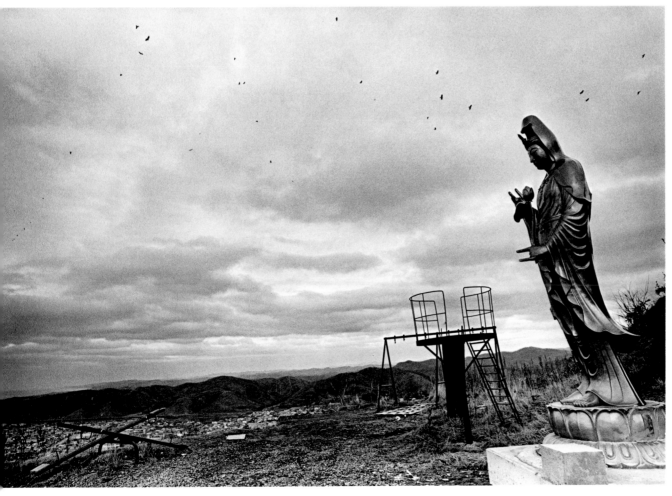

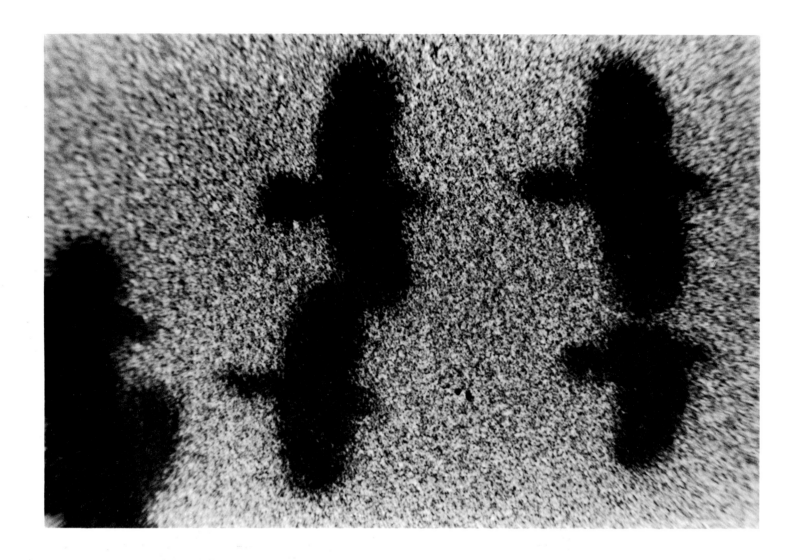

Of all the important cities of Japan, only two, Kyoto and Hiroshima, had not been
visited in strength by *B-san*, or Mr. B, as the Japanese, with a mixture of respect
and unhappy familiarity, called the B-29; and Mr. Tanimoto, like all his neighbors
and friends, was almost sick with anxiety. He had heard uncomfortably detailed
accounts of mass raids on Kure, Iwakuni, Tokuyama, and other nearby towns; he
was sure Hiroshima's turn would come soon. He had slept badly the night before,
because there had been several air-raid warnings. Hiroshima had been getting
such warnings almost every night for weeks, for at that time the B-29s were using
Lake Biwa, northeast of Hiroshima, as a rendezvous point, and no matter what
city the Americans planned to hit, the Superfortresses streamed in over the coast
near Hiroshima. The frequency of the warnings and the continued abstinence of
Mr. B with respect to Hiroshima had made its citizens jittery; a rumor was going
around that the Americans were saving something special for the city.

JOHN HERSEY, *HIROSHIMA*

And again the dark street. The dark, dark street. The women out shopping for the evening meal of course, and the baby carriage and the silver bicycle were already painted out by the darkness; most of the commuters too were already in place in their filing-drawer houses. A half-forsaken chasm of time . . .

KOBO ABE, THE RUINED MAP

森山大道

DAIDO MORIYAMA

"It's simply a fact—there are only a few images left.

"When I look out here I see everything is cluttered up. There are hardly any images to be found. One has to dig deep down like an archaeologist; one has to search through this violated landscape to find something.

"Naturally, there is a risk involved, one that I wouldn't avoid. I see only a few people who take risks in order to change this misery—the misery of having no images left, none that are adequate. We desperately need images, those images that are relevant and adequate to our level of civilization—ones that correspond to those deep inside ourselves."

WERNER HERZOG
from Tokyo-Ga, a film by Wim Wenders, a Chris Sievernich-
Wim Wenders Film Production, 1984.

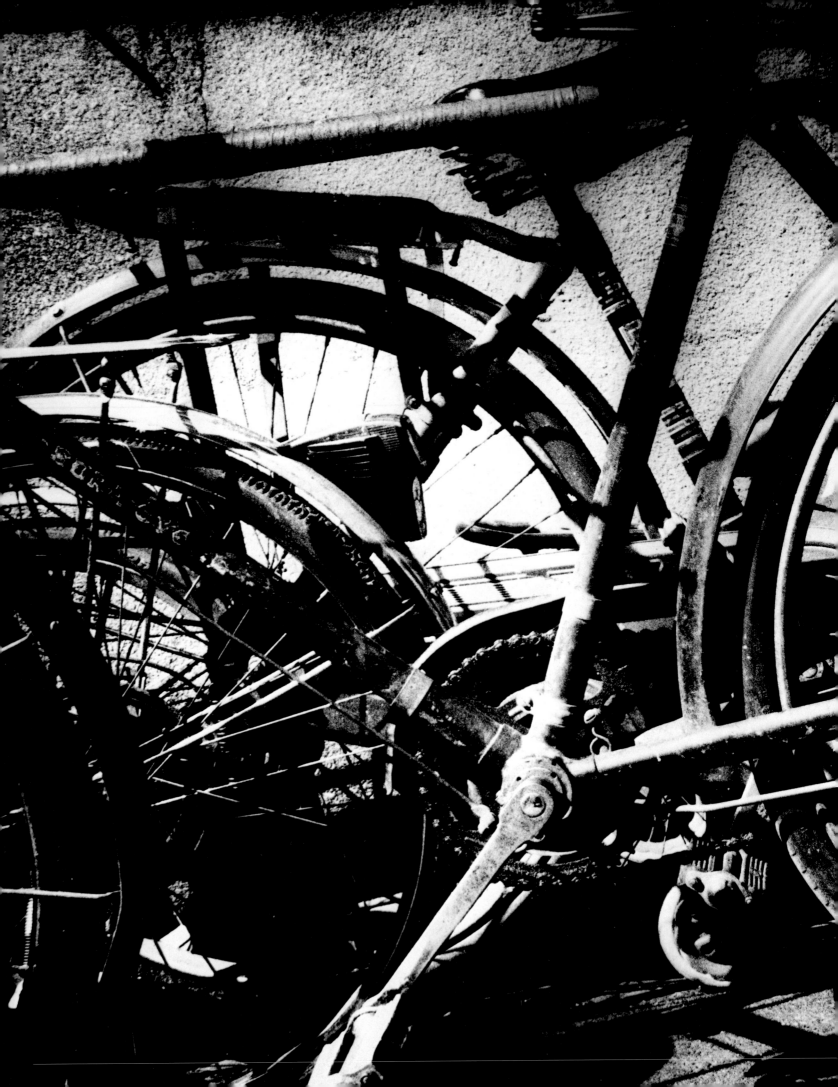

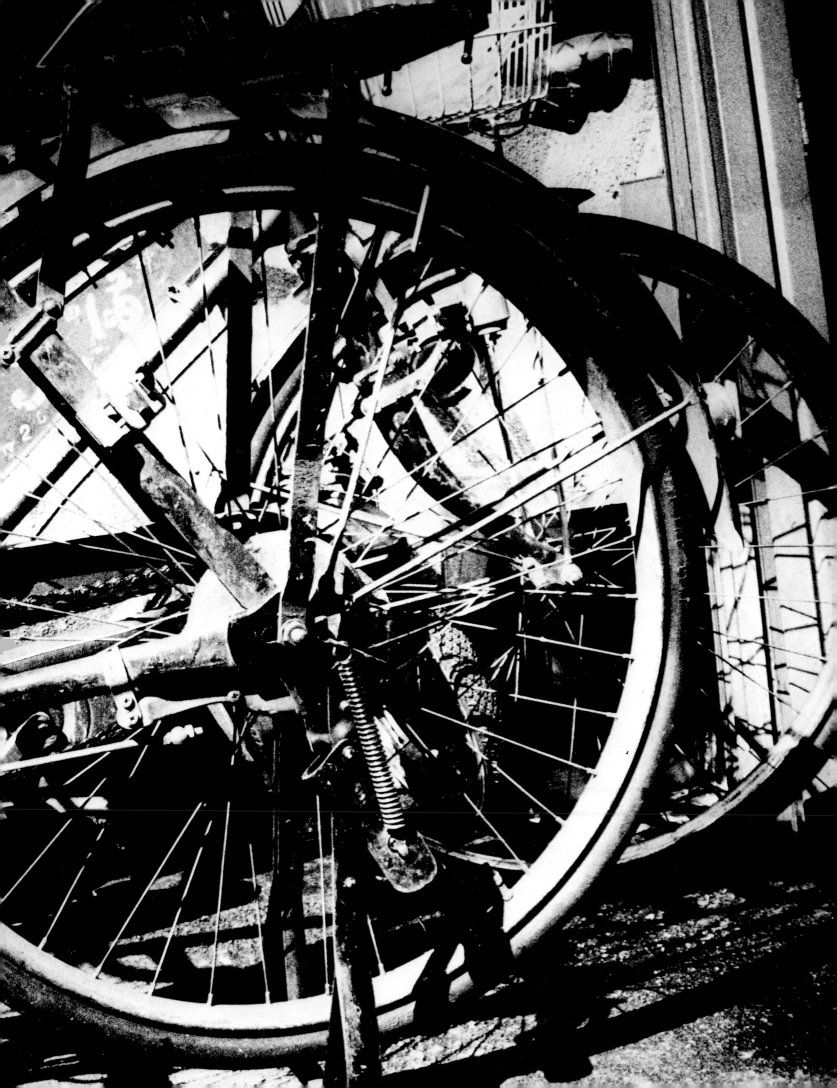

THE SURFACE OF
THE CITY

Daido Moriyama was born in Osaka in October 1938, the month the Japanese imperial army invaded Canton. When he was nine his family moved to Urawa City, where he first saw the American troops as they drove by in their jeeps tossing chewing gum to the children. Close to his home was a rubber factory that had thrived on the war effort and then fallen into dereliction. With its rusting, broken machinery, the factory was a place for children's exploration. Moriyama would sometimes take a book into the factory yard and daydream. The postwar period remained in his memory marked with the smell of rubber.

As a teenager he failed his school exams, and only through his parents' pleading was he eventually admitted to an arts-and-crafts high school in the center of the Osaka pleasure quarter, the entertainment district, where he wandered away his adolescence. His first work was in a small design company, where he produced advertising for Toei films and designed match boxes. His spare time was spent drinking, in the music hall, or playing pachinko. He dreamed of becoming a photographer. He was eventually employed by Takeji Iwamiya, an Osaka photographer renowned for his large-format landscape work and especially for his studies of Japanese gardens. Iwamiya was a great craftsman who followed a conventional and delicate Japanese aesthetic. He instilled a refined technique and discipline into Moriyama.

In 1961, the year the Vivo group was dissolved, William Klein was working in Tokyo. He was in contact with the group and even had his film processed in their darkroom. At the beginning of his book *Tokyo* (1964), *Butoh* dancers are photographed in a back alley in a style reminiscent of Hosoe. Klein's first book, which was on New York, had been published in 1956 and had reached Japan. He had established a style in correspondence to the kinetic quality of New York: ". . . I would be grainy and contrasted and black. I'd crop, blur, play with negatives. I didn't see clean technique being right for New York. I could imagine my pictures lying in the gutter like the New York *Daily News*." Tokyo extended his sense

of the dynamic of the city. Klein exposed its layers and its density. The peeling billboards and advertising provided a collage surface. The Japanese characters exaggerated Klein's fierce style. His influence was as explosive as his form. Tomatsu was closely aware of his work. In Osaka, Daido Moriyama was overwhelmed by the freedom expressed and realized how the work had developed in perfect correspondence to the fragmented nature of his own environment. To imagine one's photographs blowing in the gutter as ephemeral evidence, discarded fragments of vision, was a logical step for someone brought up in the wasteland of postwar Japan. Moriyama was also deeply impressed by the work of Tomatsu, which he had seen in magazines. Iwamiya agreed to release his young assistant and generously provided Moriyama with an introduction to Tomatsu and the Vivo group. Moriyama left Osaka at the beginning of the sixties with a camera and a suitcase and headed for Tokyo.

In *Inunokioku* (*Dog Memories*) (1984), his first book of essays, Moriyama refers to the haiku poet Buson: "Once out of the gate, I go into the dusk of autumn," wrote Buson. Moriyama inferred that the critical move was the step through the gate, which was the same if one was going to buy cigarettes or embark on a great journey. Moriyama was convinced by the analogy of life as a journey and applied the analogy to himself, stating that the journey was the route to self-discovery and the awakening of a new consciousness. He saw the journey as a means of sharpening the memory and the powers of association. He emphatically referred to time, describing the journey as a recycling of "self" or "feedback toward the future."

When he arrived at the offices of Vivo, Tomatsu explained that he was too late, Vivo was over. However, Hosoe responded intuitively to the young Moriyama and offered him work as his assistant. Hosoe, another superb craftsman, became his teacher. Moriyama often stayed the night at the old Vivo offices, which Tomatsu and Hosoe maintained. Occasionally he would stealthily

examine Tomatsu's files of contact sheets and become so excited he couldn't sleep. This surreptitious spying he described as the great influence on his work.

Over a period of two months in 1965 Moriyama photographed the American-base town of Yokosuka. Shoji Yamagishi, the most influential editor in Japan, published nine pages of the work in *Camera Mainichi*. Moriyama later included work from Yokosuka in his book *A Hunter* (1972). Tadanori Yokoo, in his introduction to the book, drew attention to the predatory and erotic qualities of the work. Stalking the back streets and the bars among the military and the whores, Moriyama displayed an aggressive voyeurism. The act of photographing was itself predatory. "Sometimes I'd take shots without aiming, just to see what happened. I'd rush into crowds—bang! bang!" said William Klein, equating the camera and the gun. Moriyama was not, however, shooting randomly. His aim was alarmingly accurate.

In the late sixties Shuji Terayama, who was establishing Tenjosaijiki, his Laboratory of Theater Play, had become a prolific essayist as well as a poet. He admired the photographs Moriyama had taken at the coast town of Atami. Terayama thought they were the most beautiful photographs of garbage that he had ever seen. He arranged to meet Moriyama with the hope of persuading him to provide photographs to accompany the forthcoming publication of his essays in a magazine. Their meeting was very short. Terayama entered the café looking more like a movie actor than a poet. He spoke very quickly, then whisked Moriyama into a taxi and took him straight to an underground theater. Theater then became Moriyama's subject. It provided a code that linked him to the elements of performance so prevalent in the Tokyo subculture of the sixties and offered a convention with which to structure the wild fragments of his innovative photographic form.

Moriyama's work in the clubs and streets of Shinjuku among strippers and other performers was published in his first book, *Japan—A Photo Theater*

(1968), a title originally suggested by Shoji Yamagishi. The grimace of an actor baring his teeth in the silent scream of a photograph was one of the most striking images of the time, reflecting in a mask of explicit pain an anguish Moriyama was drawing from the extremes of social unrest. Ten years later he collected the even greater abstractions of his style in *Japan—A Photo Theater II* (1978), a book of astonishing juxtaposition of surfaces and shifting scales that perpetuated an image of a fragmented metropolis in the almost nocturnal haze suggested by the heavy black tones of his prints.

By 1968 Moriyama had been recognized in Japan and awarded major prizes by the Japanese critics. Hosoe had insisted that he develop his work rather than serve as his assistant. Moriyama began his own publication, *Provoke*, with his friends Takuma Nakadaira and Yukata Takanashi, involving young poets as well as photographers in a provocative strategy to challenge fundamental perceptions as well as to break down the conventions of form. During the antiwar demonstrations of 1968, when the riots spread through the streets and campuses, Moriyama became deeply depressed and withdrew from the political events to push himself further into his photography. He remembers the culmination of 1968 in the Antiwar Day of October 21, when the Shinjuku riots were the greatest in Japanese history. At the height of the fierce fighting between the students and the police the storm of sound and light was displaced by a sense of silence. He watched the events like a silent movie, as if history had been transformed into spectacle. He returned to the darkroom in a mood of despair with the realization that the only course was to intensify his photography.

The silent scream of history that so impressed Moriyama in 1968 was explicitly expressed by Hijikata in the same year. *Revolt of the Flesh* was considered Hijikata's greatest performance, in which he turned his back on Western dance to embrace his own Japanese form. An 8mm film of the performance exists, and its crude, hand-held quality is evocative less of 1968 than of a turn-of-the-century

document of shamanistic rites. Almost as an extension of *Kamaitachi*, Hijikata is carried on stage beneath a sunshade and then strips down to a gold G-string and phallus. His finale was to be lowered across stage, entwined in the ropes as if he was being torn apart. Hijikata refers to the scream and identifies it in the Western tradition of Artaud, Bacon, and Munch. Tokyo is the source of his scream, and it is perpetuated through the work of the dancers he has influenced. The images of those who attempted to sever their course from borrowed traditions, a man torn apart on a stage or wrapped in bondage on his mosaic zodiac, become monumental, elevating these figures to historical positions. The film of Hijikata's *Revolt of the Flesh* is the ghost newsreel that haunts Tokyo like the silent movie of history that was ingrained on Moriyama's imagination.

The route to Moriyama's small studio in an old Shibuya apartment house is through narrow streets with love-hotels and bars in a hilly back quarter. The experience of walking with Moriyama through the lanes corresponds to the process of his work. His camera records the motion of the eye across the surfaces of barroom doors, from the tarmac of the street below to the clouds above the telephone wires. The eye equates the surfaces: the fur of a prowling dog matches the texture of a woman's dress or a girl's hair or the shadows on the wall at the end of a blind alley. Moriyama may have learned much from William Klein, but his other debt is to Atget. The lanes of Atget's Paris, a city under reconstruction, frequently acquired a sinister quality of incipient drama, once described as the scene of a crime. Moriyama inhabits a threatening world, with the possiblilty of a knife drawn from behind, or he walks stalked by his own shadow.

When Walter Benjamin practiced the art of losing himself in the city, he wanted the surprise, the mystery, of the unknown alley leading nowhere and the heightened drama it provided. Moriyama's domain is between his studio and the bars of Shinjuku's Golden Gei, the pleasure quarter, like that of Osaka through which he wandered as an ado-

lescent. It occupies an enclave of tiny houses on a grid of alleys tucked away from outsiders and inhabited by a mysterious population, sometimes referred to as "cat people." They dart from the shadows and vanish with a proposition. Moriyama held court one night with his colleague Fukase in the upstairs room of a Golden Gei bar that had space for a single table. He took me to the top floor, where photographs were pinned to the wall as in a hidden gallery from a subculture nearly twenty years before. Outside the bar the lights of Shinjuku were blazing, the strippers warming up, and the gangsters strutting in their white suits. The nocturnal life of the city proceeds, a constant since the time of Edo, despite the statistics of the GNP, an emperor who lost his divinity, or a digital clock that counts down the days to the Scientific Expo at Tsukuba. Moriyama's journey is through the labyrinths of Shinjuku and Shibuya. The lines that the characters of this text, whether photographers, poets, dancers, or writers, have drawn all point inward on a map, crossing and overlapping. If you reached their source you would be standing at the center of a maze. Moriyama has already developed the strategy that Walter Benjamin described: he is practiced in the art of losing himself. A maze is his natural habitat.

On a poster at a Tokyo station I see an exhibition advertised as *After Man: The Zoology of the Future*, and I catch a train to Nara, the eighth-century capital. It is the 1,150th anniversary of the birth of the Buddhist teacher Kobo Daiishi. In the remote temple of Koiyasan he is celebrated in a percussive symphony by S'tomu Yamashta. The monks chant sutras against a laser backdrop. In Hiroshima the peace march gathers beneath the Atomic Dome. I move from Nara to the Asuka plain and the tumuli of the earliest Yamato emperors. In a clear midsummer light, as perfect as a summer more than forty years ago when pilgrims walked beneath an untroubled sky, I follow the hillside track, Yamanobe no michi. It is the ancient path between the imperial graves, a thin line on the map.

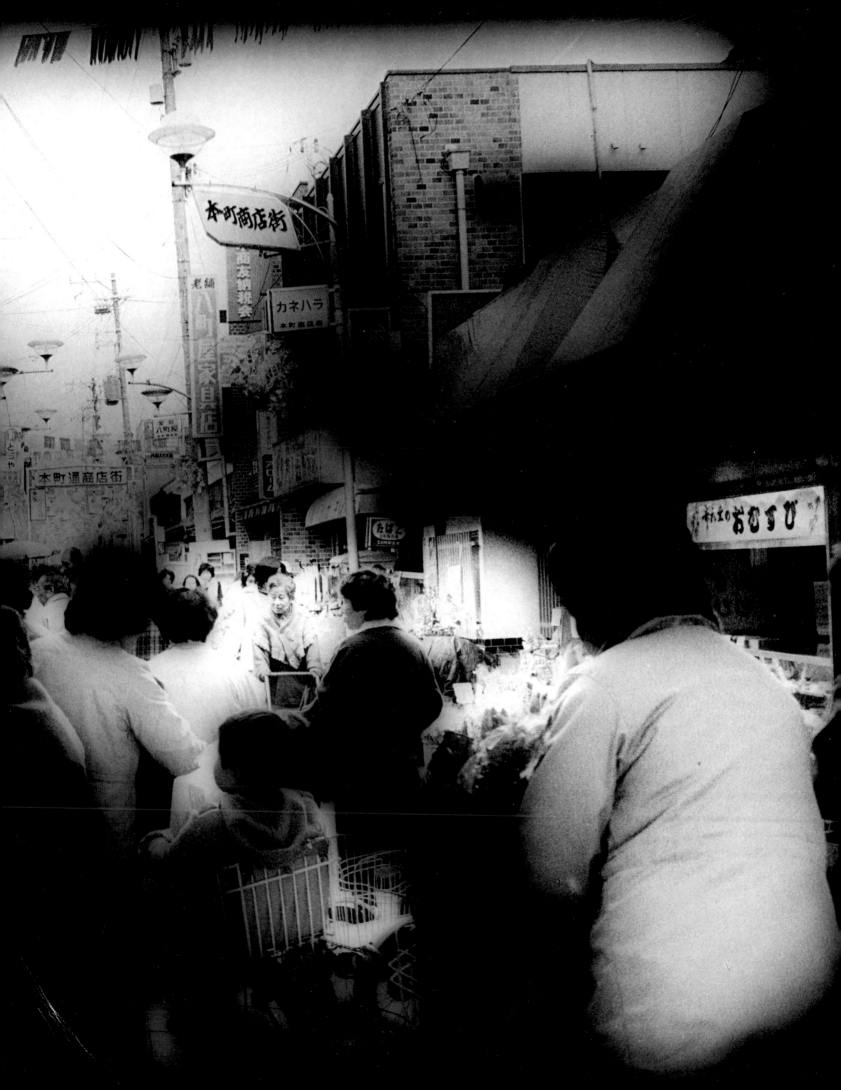

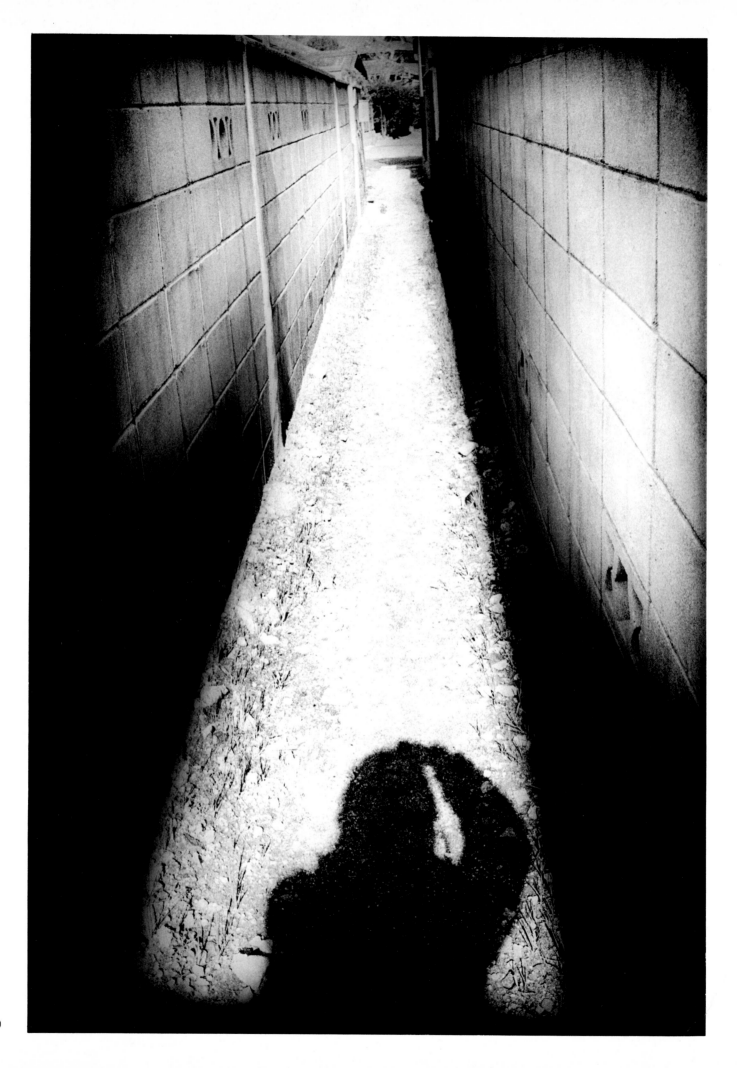